the best of

TEEN AND SENIOR PORTRAIT PHOTOGRAPHY

Techniques and Images
from the Pros

Bill Hurter

AMHERST MEDIA, INC. ■ BUFFALO, NY

Front cover photo: Brian King © 2003
Back cover photo: Fuzzy Duenkel © 2003

Published by:
Amherst Media®
P.O. Box 586
Buffalo, N.Y. 14226
Fax: 716-874-4508
www.AmherstMedia.com

Publisher: Craig Alesse
Senior Editor/Production Manager: Michelle Perkins
Assistant Editor: Barbara A. Lynch-Johnt

ISBN-13: 978-1-58428-111-5
Library of Congress Control Number: 2003103023

Printed in Korea.
10 9 8 7 6 5 4 3 2 1

Notice of Disclaimer: The information contained in this book is based on the author's experience and opinions. The author and publisher will not be held liable for the use or misuse of the information in this book.

TABLE OF CONTENTS

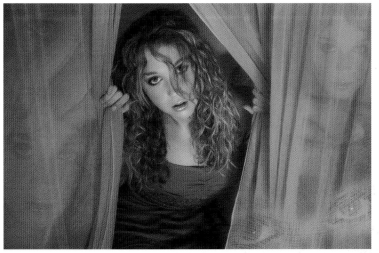

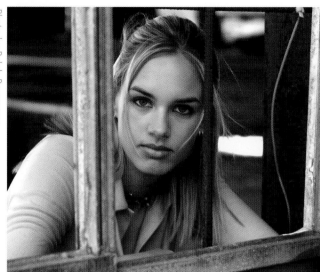

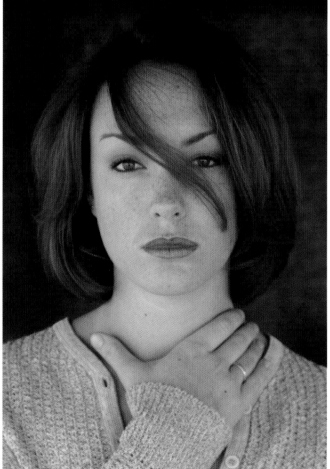

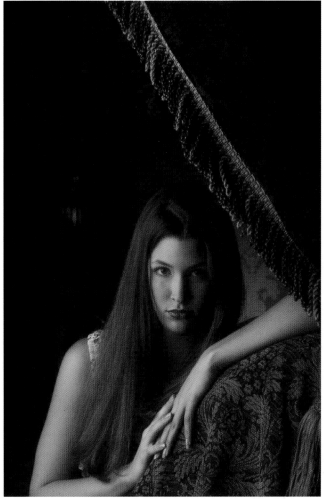

Photo by Larry Peters.

Michael J. Ayers *(PPA-Certified, M.Photog.,Cr., APM, AOPA, AEPA, AHPA)*. WPPI's 1997 International Portrait Photographer of the Year, Michael Ayers is a studio owner from Lima, Ohio. He has lectured to photographers about weddings, portraiture, and album design all across North America and has been a featured speaker in Europe. Michael and his wife Pam are considered among the best wedding album designers in the world. Their creations and constructions have been honored as numerous Master's Loan Collection albums and they have received honors in the WPPI Awards of Excellence print and album competitions. Visit the Ayers studio web site at www.theayers.com.

Gigi Clark. With four college degrees, Gigi Clark has a varied background including multimedia, instructional design, graphic design, and conceptual art. She brings all of her multidisciplined talents to her upscale photography business located in Southern California. She has received numerous awards and honors including several First Place awards in both PPA and WPPI competitions, as well as the first-ever Fujifilm Award for "Setting New Trends." For more information, or to view Gigi's images, visit her web site at www.ritualsphoto.com.

Fuzzy Duenkel *(M.Photog.,Cr., CPP)*. Fuzzy and Shirley Duenkel of West Bend, Wisconsin operate a thriving portrait studio concentrating primarily on seniors. Fuzzy has been highly decorated by PPA, both nationally and in Wisconsin, having won nine Photographer of the Year Best of Show, and Photographers' Choice awards at Wisconsin PPA senior folio competitions. Fuzzy has had twelve prints selected for the National Traveling Loan Collection, two for Disney's Epcot Center, one for Photokina in Germany, and one for the International Photography Hall of Fame and Museum in Oklahoma. Fuzzy's custom senior portraits, created in and around his subjects' homes, allow and encourage an endless variety. To see a sampling of Fuzzy's portraiture, visit his web site at www.dueknel. com.

Ira and Sandy Ellis. This team of photographers owns and operates Ellis Portrait Design in Moorpark, California. The Ellis team, in addition to shooting twenty or so weddings a year, pro-

duces children's fantasy portraits, high-end images created around an imaginative concept. Both Ira and Sandy have been honored in national print competitions at PPA and WPPI and have had their work featured in national ad campaigns.

Don Emmerich *(M.Photog., M.Artist, M.EI, Cr., CEI, CPPS).* Don Emmerich is a virtuoso of the visual arts and one of the pioneers of applied photographic digital imaging. He belongs to a select group of professionals who have earned all four photographic degrees; he was also chosen to be a member of the exclusive Camera Craftsmen of America society, which is comprised of the top-forty portrait photographers in the United States. Don has been PPA's technical editor for the past twelve years, with some 150 articles published in various magazines, nationally and internationally. For more information, or to view Emmerich's images, visit his web site at www.emmerichphoto.com.

Gary Fagan *(M.Photog,Cr., CPP).* Gary, along with his wife, Jan, owns and operates an in-home studio in Dubuque, Iowa. He concentrates primarily on families and high-school seniors, using his half-acre outdoor studio as the main setting. At the 2001 WPPI convention, Gary was awarded WPPI's Accolade of Lifetime Excellence. He was also awarded the International Portrait of the Year by that same organization. At the Heart of America convention, he had the Top Master Print and the Best of Show. For the highest master print in the region, Gary received the Regional Gold Medallion Award at the PPA National convention ASP banquet.

Deborah Lynn Ferro. A professional photographer since 1996, Deborah Lynn often calls upon her background as a watercolor artist to enhance her images. She has studied with master photographers all over the world, including Michael Taylor, Helen Yancy, Bobbi Lane, Monte Zucker, and Tim Kelly. Deborah is working toward degrees from WPPI and PPA. In addition to being a fine photographer, she is also an accomplished digital artist. For more information or to view Deborah Lynn Ferro's work on the web, visit her at www.rickferro.com.

Frank A. Frost, Jr. *(PPA-Certified, M.Photog.,Cr., APM, AOPA, AEPA, AHPA).* Located in the heart of the Southwest, Frank Frost has been creating his own classic portraiture in Albuquerque, New Mexico for over eighteen years. Believing that "success is in the details," Frank pursues both the artistry and business of photography with remarkable results, earning him numerous awards from WPPI and PPA along the way. His photographic ability stems from an instinctive flair for posing, composition, and lighting. Visit Frost on the web at www.frankfrost.com.

Tim Kelly. Tim Kelly has won almost every available photography award. He not only holds Master of Photography and Photographic Craftsman degrees, but he has amassed numerous awards, including: PPA Loan Collection, Kodak Gallery, Gallery Elite, and Epcot Awards. Kelly, a long-time member of Kodak's Pro Team, has been under the wing of their sponsorship since 1988. In 2001, Kelly was awarded a fellowship in the American Society of Photographers and was named to the prestigious Cameracraftsmen of America. The Photography Hall of Fame in Oklahoma City also displays a Kelly portrait and an album of images in their permanent collection. Kelly Studio and Gallery in the North Orlando suburb of Lake Mary, Florida, is the epitome of a high-end creative environment. Visit Kelly's web site at www.timkelly portraits.com.

Brian King. Brian King of Cubberly Studios in Ohio began accumulating awards for his artwork in elementary school. He attended the Ohio Institute of Photography, graduating in 1994. He went straight to work at Cubberly Studios in Ohio, where he is still employed. Earning both his Certified Professional Photographer and Master Photographer degrees from PPA, he is a member of PPO-PPA Senior Photographers International and the American Society of Photographers. To see a sampling of King's portraiture, visit www.cubberly.com.

Robert Love *(APM, AOPA, AEPA, M.Photog,Cr., CPP)* and **Suzanne Love** *(Cr. Photog.).* Robert Love is a member of Cameracraftsmen of America, one of forty active members in the world. He and his wife, Suzanne, create all of their images on location. Preferring the early evening "love light," they have claimed the outdoors as their "studio." This gives their images a feeling of romance and tranquillity.

Tammy Loya. Tammy Loya is an award-winning children's portrait specialist from Ballston-Spa, New York. In her first WPPI Awards of Excellence print competition last year, she won a first and second place in the "children" category. All her other entries received honorable mentions. Her studio is a converted barn, which includes a Victorian theater, known as the Jail House Rock Theater, for previewing her client's images. To see a sampling of Loya's portraiture, visit her web site at www.tammyloya.com.

Ralph Mendez (*Cr.Photog.*). Ralph Mendez and his wife, Rosemary, operate Images Designer Portraits in Riverside, California. Their main mentors have been Bruce and Sue Hudson, Charles Lewis, and Larry Peters. Their marketing mix includes weddings, seniors, families, and black & white portraiture. Ralph Mendez is regarded as one of the up-and-coming senior photographers in the country.

Richard Pahl. Rick Pahl is a highly successful senior and portrait photographer from Okeechobee, Florida. He is a digital wizard and has taught nationally on using Adobe® Photoshop® as a creative and production tool. He is one of the few photographers to ever score perfect 100s in both WPPI and PPA print competitions. For more information, visit www.richardpahl.net.

Larry Peters. Larry Peters is one of the most successful and award-winning teen and senior photographers in the nation. He operates three successful studios in Ohio and is the author of two books, *Senior Portraits* (Studio Press), published in 1987, and *Contemporary Photography* (Marathon Press, Inc.), published in 1995. His award-winning web site is loaded with information on photographing seniors: www.petersphotography.com.

Norman Phillips (*AOPA*). Norman Phillips has been awarded the WPPI Accolade of Outstanding Photographic Achievement (AOPA), is a registered Master Photographer with Britain's Master Photographers Association, is a Fellow of the Society of Wedding & Portrait Photographers, and a Technical Fellow of Chicagoland Professional Photographers Association. He is a frequent contributor to photographic publications, a print judge, and a guest speaker at seminars and workshops across the country. For more information, you can visit Norman Phillips on the web at www.normanphillipsoflondon.com.

Barbara Rice (*Cr.Photog., PFA, APM*). Barbara Rice has been a professional photographer for twenty-two years working in Pennsylvania, New York, and Ohio. An accomplished artisan, Barbara has received top honors in several photographic competitions. For more information on Barbara's work, or to view more of her images, visit her website at www.ricephoto.com.

Patrick Rice (*M.Photog.Cr., CPP, AHPA*). Patrick Rice is an award-winning portrait and wedding photographer with over twenty years in the profession. A popular author, lecturer, and judge, he presents programs to photographers across the United States and Canada. He has won numerous awards in his distinguished professional career, including the International Photographic Council's International Wedding Photographer of the Year Award, presented at the United Nations. For more information on Patrick's work, or to view more of his images, visit www.ricephoto.com.

Ralph Romaguera. Ralph Romaguera is a highly successful senior and teen photographer with three thriving studios in the greater New Orleans area. Ralph and his sons Ryan and Ralph, Jr., also successful photographers, operate his three studios. He can be reached at his web site: www.romaguera.com/seniors.html.

Jeff Smith. Jeff Smith is an award-winning senior photographer from Fresno, California. He owns and operates two studios in Central California. He is well recognized as a speaker on lighting and senior photography and is the author of *Outdoor and Location Portrait Photography, Corrective Lighting and Posing Techniques for Portrait Photographers, Success in Portrait Photography,* and *Professional Digital Portrait Photography* (all published by Amherst Media) and the self-published title, *Senior Contracts.* He can be reached at his web site, www.jeffsmithphoto.com.

Ellie Vayo (*PPA Certified, M.Photog.,Cr., CPP*). Ellie Vayo has been photographing high school seniors for over twenty-five years. Ellie owns one of the most successful senior studios in the country today, located in Mentor, Ohio, about twenty-five miles east of

Cleveland. She is part of the Fuji Talent Team, and she created the "Ellie Vayo Senior Album" in partnership with General Products. Ellie lectures throughout the country at many major state conventions. Her marketing CD-ROM "business card" recently won the First Place AN-NE Award trophy at PPA's Senior Marketing Conference! Amherst Media published her first book, *The Art and Business of High School Senior Portrait Photography*, in the fall of 2002. For more information or to view Vayo's work, visit her web site at www.evayo.com.

Monte Zucker. When it comes to perfection in posing and lighting, timeless imagery, and contemporary, yet classical photographs, Monte Zucker is world famous. He's been bestowed every major honor the photographic profession can offer, including WPPI's Lifetime Achievement Award. In 2002, Monte received the International Photography Council's International Portrait Photographer of the Year Award, presented at the United Nations. In his endeavor to educate photographers at the highest level, Monte, along with partner Gary Bernstein, has created the information-based web site for photographers, www.Zuga.net.

Seniors and teens are an age group in transition. They often have boyfriends or girlfriends and are thinking about college or career, and they're often thinking about leaving home, all of which can make for a very confusing time of life. A portrait made at this stage of their lives is a valuable heirloom because they will never look or act quite like this again.

Award-winning photographer Rick Pahl sees senior-age kids as being at the pinnacle of their physical attractiveness. "On a Darwinian level," says Rick, "seniors, especially girls, are at or are very close to their physical primes. This is when girls are the most attractive. Men are usually considered their best at around

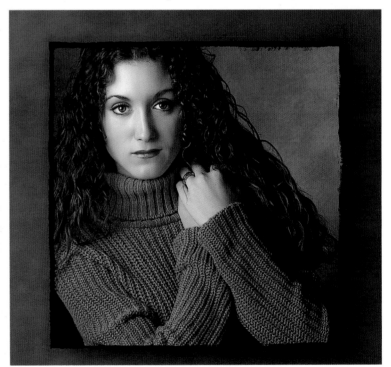

The art of senior portraiture has evolved to create new standards of excellence. Here award-winning photographer Tim Kelly has created an elegant but very contemporary senior portrait by mixing classical and casual elements.

Above—Deborah Lynn Ferro, a relative newcomer to senior portraiture, combines her skills as a watercolor artist and her eye as a photographer to create some of the freshest senior portraits in the country. Here she has given the image a canvas-like effect in black & white. Right—Richard Pahl is also a newcomer to photographing seniors, but he brings life and fun and a sense of innovation to the genre. A Photoshop master, Pahl has created a monochrome print with only one area of color, the slate blue eyes of the senior. This image is a national award-winner.

twenty-five, but senior boys are most definitely showing signs of physical maturity."

A "contract photographer" usually does senior portraits at the schools on picture day, but that is not the type of senior portraiture that will be considered here. Many studios have taken to offering high-end, very hip and upscale senior sittings that allow the kids to be photographed with their favorite things in their favorite locations. For instance, a senior's car, usually a treasured possession, is a prime prop included in these sessions. Often senior sessions will involve the subject's friends and favorite haunts. Or, in the case of senior girls, they will want to be photographed in a fashion or glamour pose, wearing something pretty racy—like what they see on MTV. This is all part of the process of expressing their individuality and becoming an adult and, instead of resisting it, many smart photographers are now catering to it.

One of the biggest differences between teens and young children is that the teens think of themselves as individuals. They will often have unique clothes or hair (or tattoos or piercings) that set them apart. A good senior photographer, instead of reacting negatively to their uniqueness, will react with apprecia-

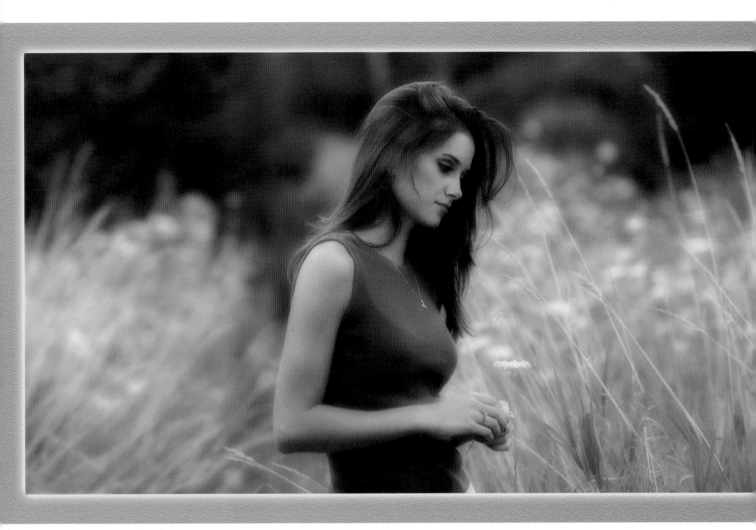

Fuzzy Duenkel is an expert at bringing out the feelings of his senior subjects. He forges a strong connection with the senior by working in locales familiar to the young person. Fuzzy works primarily with available light and a home-made reflector, composed of building insulation material and a Mylar mirror.

tion. If you earn their respect, they will be much more involved in the photography.

Rick Pahl's senior images are full of life and fun. The main reason is simple—Rick genuinely likes "his kids," as he calls them. He says, "I really like teens! All the teens I shoot become one of 'my kids.' I've learned that full and honest respect for someone between thirteen and seventeen years of age is essential. I talk to them as though they are

adults. I kid with them in the same way. All my kids become part of the year's 'Dream Team' and a copy of their portrait hangs in a place of honor in our little town's (Okeechobee, Florida) best art gallery."

Rick believes posing seniors is relatively easy. He says, "My wife, Kat, helps greatly with the posing, and we work as a team with the models. We refer to all our clients as 'models' and we treat them as such." On his shooting regimen, Rick comments, "I usually don't begin to get good shots until we're around the tenth exposure or so. By then, smiling and posing is 'old hat' and we can start getting down to business. I shoot where and what the kids like—a

clothes-oriented girl gets a fashion shoot. An aspiring male model gets a jeans 'ad.' The 'horse' set gets horses, and western kids get old corrals and western gear."

Rick Pahl obviously has a knack with this age group, but for those photographers who want to build their businesses through senior photography, there are a number of essentials to success. Experts say to make the photo session fun, but not in some phony way that the kids think is corny. Be yourself, but be excited and like kids of all ages; they will react positively to your enthusiasm and positive energy as long as they feel it's genuine.

Treat teens like adults and they will respond like adults, or at least

they'll try to. Ask them about their lives, their hobbies, their likes and dislikes, and try to get them to open up, which is not always easy. Some teens are introspective and moody, and it will take all of your social skills to bring them out.

You may have to be less in control in a senior setting than with younger children. Teens want to feel that they have control, particularly over their own image. You should suggest possibilities and, above all, provide reassurance and reinforcement that they look great.

As with any good portrait sitting, the aim is to show the different sides of the subject's personality. While adults have all sorts of armor and subterfuge that prevent people from seeing their true natures, teenagers aren't nearly as sophisticated. Like adults, however, teens are multi-

faceted. Try to show their fun side as well as their serious side. If they are active or athletic, arrange to photograph them in clothing associated with their sport or activity.

Clothing changes help trigger the different facets of personality as do changes in location. When you meet with the teen and his or her parents before the photo session, suggest that he or she bring along a variety

of clothing changes. Include a formal outfit (like a tux or suit), a casual "kickin' back" outfit (shorts and T-shirt), an outfit that is cool (one that they feel they look really great in), and an outfit that represents their main interest (a baseball jersey and cap or cheerleader's outfit or letter jacket).

You can also encourage teens to bring in their favorite things, includ-

Above—Rick Pahl gives "his kids" what they want. Here he has transformed a barn and corral scene into sepia tones but preserved the senior in color. You can even see the spider webs in the background. Because Pahl records all his senior work digitally, transformations like this one are second nature. **Right**—Any fine portraitist knows that the discovery of personality is the aim of the portrait session. Here, Richard Pahl has created a moody and thoughtful portrait of a senior who seems to glow from within. He has blended the highlights and shadows so delicately in Photoshop that the girl's skin is almost translucent.

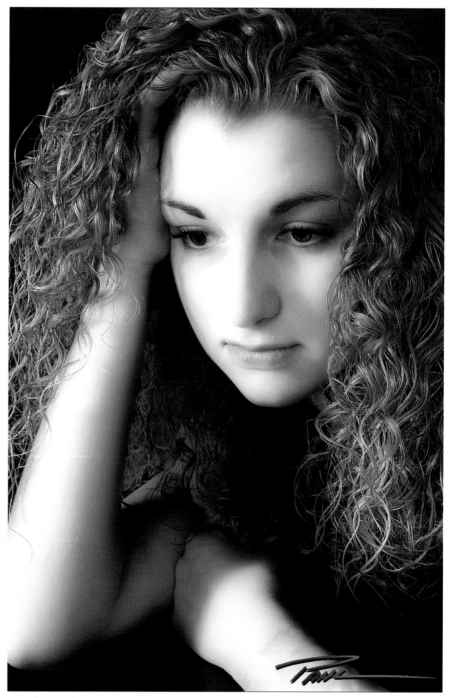

ing pets. This will help reveal their personalities even more, and like little kids, the presence of their favorite things will help them feel relaxed and at home.

It pays to be sensitive to the particular concerns that teens have about acceptance among their peers. They want to feel that they fit within the mainstream of others their own age. This likely means that they are nonconformists in the adult world, but that they are part of what's happening in their own world. As an expert at photographing this age group, you need to be aware of the latest trends in clothing and hairstyles, music and art (movies and TV), and try to be sensitive to their requests for particular settings and poses. It helps if you have kids in this age group (at least you'll know some of the bands on MTV), but if you don't, it will be helpful to develop a working knowledge of popular teenage culture. A genuine interest won't hurt. One very successful senior photographer, Larry Peters, says the kids that come into his studios (he has three in Ohio) are always blown away by the selection of CDs he has on hand, including rap and hip hop. Peters has all types of music available, but he also knows about the music so that when he puts on one of the CDs, the kids relax and start enjoying the experience, which is more than half the battle.

For teens, it is necessary to let them feel that they have control. While in many other types of fine portraiture, like children's portraiture, control is of the essence, this is not true for seniors and teens. This age group knows what they want and it's up to you to provide it.

High school seniors are extremely Internet savvy, something that is very clear to Ralph Romaguera and sons, who own three prestigious studios in the New Orleans area. Ralph Jr. has created an attention-getting web site that, in 2001, won the Senior International Web Site of the

One of the elements of great senior portraiture, especially of senior girls, is the aspect of glamour. Here, Larry Peters has combined an elegant pose and interesting props and background, along with a carefully feathered key light to create a beautiful portrait in which the girl's natural beauty is illuminated.

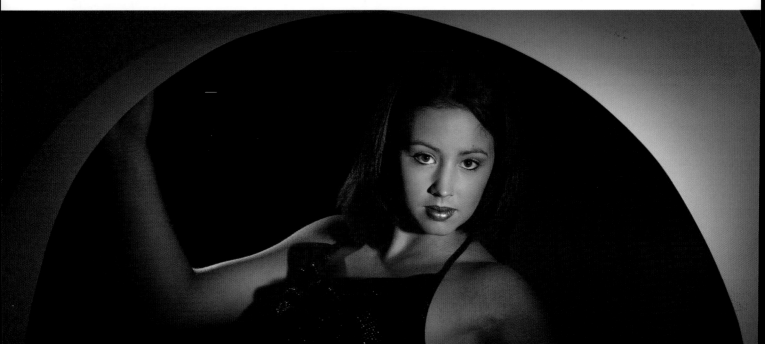

Year Award from Senior Photography International, a Florida-based organization that is dedicated to this market. The Romaguera site provides a range of information and a gallery of photographs that not only spotlight the quality of the studio's services but also encourage potential clients to be involved in all phases of the planning of their portrait session. The site provides as much information as possible and asks the questions the kids themselves may not want to ask, like "What about zits?" The web site, like the Romagueras' photography, is hip and interactive, and when the kids see what the studio is capable of, they are already sold.

Brian King, the creative eye of Cubberly Studios (there are four studios in Ohio), along with Rod and Sheila Farley, has created a very exciting web site with streaming video (www.cubberly.com), top-quality audio, and a printed "Session Guide" that answers every conceivable question a potential client might have. When visiting the web site and particularly the "Seniors" section, be prepared to stay a while

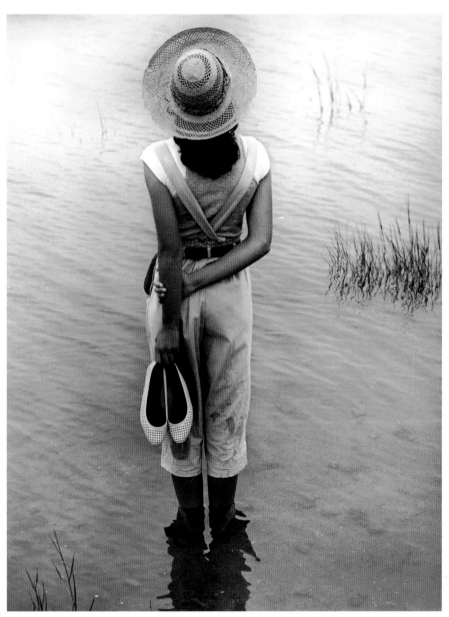

Seniors are one of the most discriminating groups of consumers out there. Their exposure to popular art and culture make them discriminating customers. Here, a fine-art type image by Gigi Clark called *Sweet Serenity* expresses a great deal about the girl's personality.

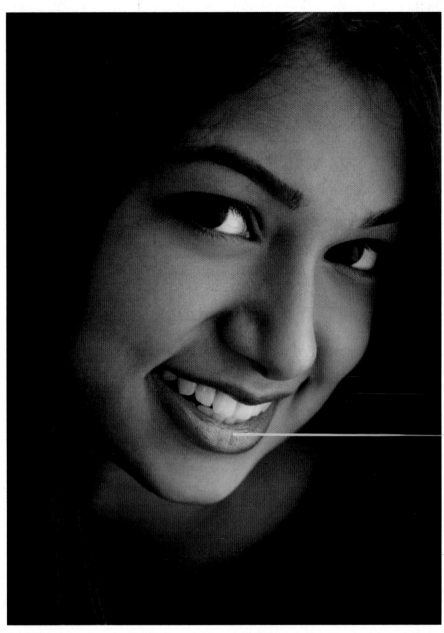

Brian King knows exactly what seniors want to see in their portraits—they want to look themselves. King's elegant lighting and minimal retouching and close-up viewpoints provide just the "edginess" to the compositions to make them a big hit with the studio's senior clients.

should be doled out in conservative and realistic doses. It is often said that one of the ingredients of a great portrait photographer is an ability to relate to other people. With teens, a genuine interest in them as people can go a long way.

The senior photographer is in the business of providing lasting memories. These kids will, as the saying goes, "never pass this way again." Like the bride on her wedding day, these people will never look so good, so strong, or so vital, or have that slim a waistline ever again. The role of the senior photographer is to create stylized impressions of these fleeting days.

As I began to research this book I became acquainted with the many wonderful photographers who concentrate primarily on senior and teen images. They are a specialized group, but like the people they photograph, senior photographers tend to be animated and full of life, and they are willing to share (thankfully) the many secrets of fine senior photography. I wish to thank the many fine teen and senior photographers and new friends who have participated in creating this book. Without their help, it would not have been possible.

and enjoy it. It is very entertaining, no matter what your age.

When a senior looks through their proofs, they expect to see a variety of poses and looks, as well as some style and sensitivity in the images. They will probably like the images in which they look themselves and the ones that reveal their true natures. This could include either the casual poses or the formal ones. If you are smart, you will have

a selection of in-studio images and outdoor portraits; a selection of the young person alone; and a few with his or her session companions. And if the teen took the trouble to bring along some of his or her favorite things, be sure to make a selection of images that includes these items.

Part of your job is to make your subjects feel good about themselves, which can take the form of reassurance or flattery, both of which

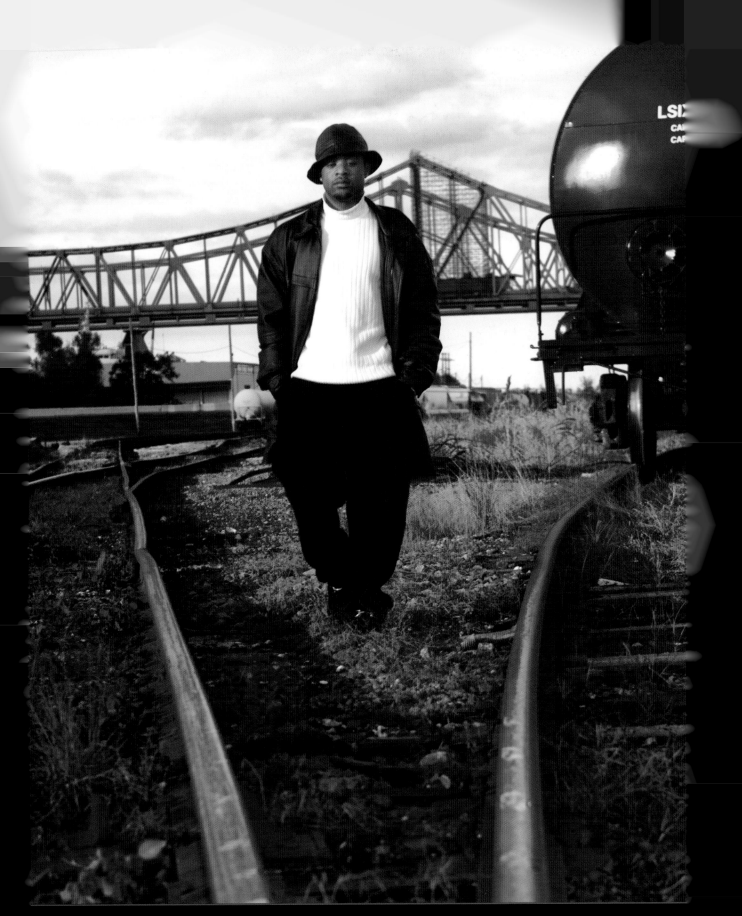

Today's senior photographer listens to the kids when they talk about what they want to see in their photographs and, in fact, even encourages experimentation and innovation. Here, a Ralph Romaguera portrait "pushes the envelope" of senior portraiture. Notice the effective design elements—the

1

SENIOR PORTRAIT PHOTOGRAPHY: YESTERDAY AND TODAY

Most of us, when we think of senior photography, think of the photographer who came to our high school on photo day to photograph us for our high school yearbooks . . . with our eyes closed. Well, he didn't come to do that exactly, but he took two poses (head turned left and head turned right) and you (or, actually, *I*) blinked for both of them. My senior portrait was hardly memorable, although I did make the yearbook, and the jokes that were scribbled on my page really made up for the fabulous portrait session.

The person who did this was a contract photographer. His studio was under contract to photograph each and every senior for the yearbook. Contract portraiture has historically suffered from excessive standardization—the same lighting was used for each person, the poses and expressions were not tailored to the individual's needs or personality, and the images were all the

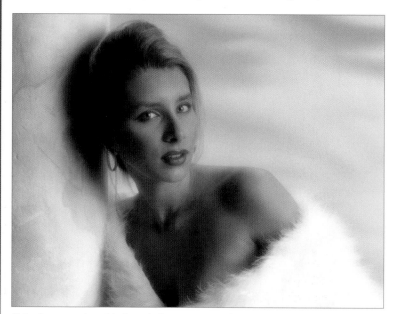

This elegant and sophisticated glamour portrait by Norman Phillips does not even remotely resemble the cookie-cutter senior portraits of only a few years ago.

same size. Like the passport photo, nobody takes a really good photo under these conditions.

So why do schools employ contract photographers? Because the studio owners essentially pay for the contracts—usually by doing activity photos at no charge or giving free supplies and use of cameras to the school's photography class. Contract photographers simplify (for the school) the process of getting photos of teams, dances, band groups, graduation, etc. The studios, in turn, make money on reprints—so if the seniors want more than eight wallets, it will cost them.

Contracts still exist today—and the work tends to be much better than it was in the past (see pages 23–24)—but the message that today's fine senior portrait photographer is sending to juniors is: "You have the right to pick the photographer of your choice."

This is the message that award-winning senior photographer Ellie Vayo continually repeats on her web site (www.evayo.com). Her web site even goes on to say (directed to the parents), "By law, no individual or organization can tell you where to spend your money. Your son or daughter's senior portrait is very important. It will follow them for the rest of their life. Consider your options carefully."

Even if the school has a contract photographer for the yearbook photos, Ellie's studio creates a custom yearbook portrait for her students. She then gets the image to the right person (the yearbook coordinator) by the right date, and confirms that

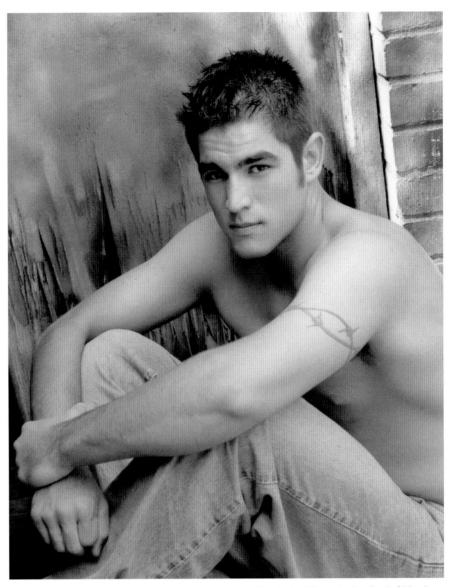

Seniors want to feel good about who they are and how they look. This senior is proud of his physical condition and his tattoo. Notice how the portrait is serious in tone, but very pleasant, nonetheless. Photograph by Ellie Vayo.

they received the photo so her students are pictured in the yearbook. She has been in the senior photography business for over twenty-five years and knows all of the yearbook submission dates for all the area high schools like the back of her hand.

In the past, contract photographers often locked up all the area high schools. Portraits by non-contract studios were not accepted for the yearbook, and students were literally forced to buy from the officially sanctioned studio. Today that practice has largely disappeared, and most of the large contract studios have lost their stranglehold on the senior business. The result is that smaller studios, which generally offer better service and higher photographic quality, have moved in to fill the void.

Yearbooks

Part of what a good senior photographer does is to offer yearbook portraits. While a contract studio might do the yearbook portraits for many

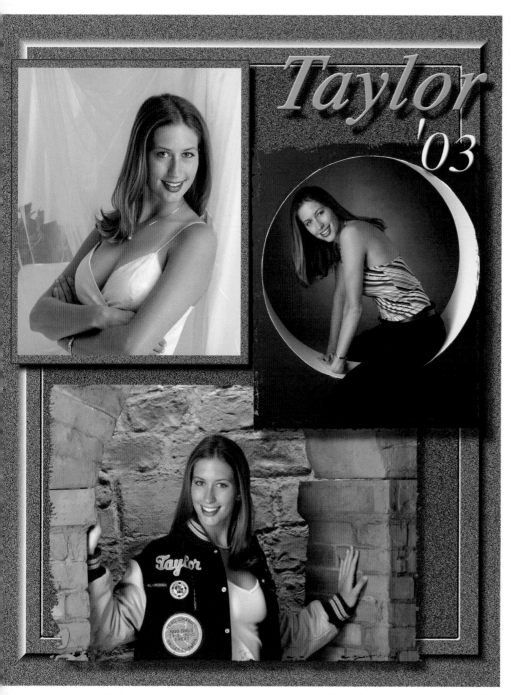

Jeff Smith regularly produces composites for his senior clients that incorporate several of the poses made for the senior session. Since Smith now shoots most of his senior work digitally, this type of creation is easy and popular among seniors. It is also a premium sale. Smith's web site features a page of "Yearbook Information" and includes links to all of the area high schools, so that seniors can obtain up-to-date information on contacts, dates, and other pertinent data.

high schools, the system is more open now, so that students can, generally speaking, go to the studio of their choice for yearbook and other senior session portraits. Photographers who cater to the senior market will explain all of this in their literature or on their web sites since most students and parents find it confusing the first time through the system. There are, in fact, some "closed yearbook" high schools that still rigidly insist that yearbook portraits be done by the contract photographer's studio. The good senior photographer's web site or literature explains this to its potential clients, and informs potential clients of which high schools accept yearbook photos from non-contract photographers and which ones don't.

Photographers like Jeff Smith, a Fresno, California-based senior photographer, make it their business to keep seniors informed of the right thing to do. Smith's web site cautions, "To find the correct studio to take your senior yearbook portraits, call your high school office. Remember that if the photos aren't taken by this studio, your portrait will probably not be allowed in the yearbook." That's good information that translates into goodwill among senior clientele. Smith's web site even goes so far as to offer links to the various area high schools in the Central Coast area of California. The links provide specific information about yearbook requirements, dress codes, dates, contact information, and more for each high school. The web site is a one-stop clearinghouse of information about senior pictures. In addition, the site recommends that students sign up for an additional session, choosing from one of many of Smith's more unusual but popular senior sessions.

School Dress Code. The basic requirements for all yearbook portraits are very similar. No matter what kind or type of clothing the high school requires, it must be within school dress code. There is also a code that applies to hair, facial hair, jewelry, piercings, length of shorts, height of socks, and so on.

Clothing may not have offensive or gang-related logos, and may not feature alcohol, drugs, tobacco, or other illegal (for minors) substances.

Girls' tops cannot be revealing, see-through, or low cut. Hats cannot be worn in most yearbook photos—this includes the cap and gown, fashionable hats, and cowboy or baseball hats. These rules are set forth by the school to represent the look they feel appropriately represents their students and parents.

There are also specifications for the pictures that must be adhered to. For example, the "head size" must be the same throughout. Prints submitted must adhere to this policy. This is so the students' pictures have uniformity throughout the senior section. The print must be of a certain size so that the yearbook publisher does not have to scan different size prints.

Deadlines. Yearbook deadlines for pictures cannot be missed. The penalty for missing or delaying deadlines can easily cost the school hundreds of dollars per day. High schools, characteristically, must have

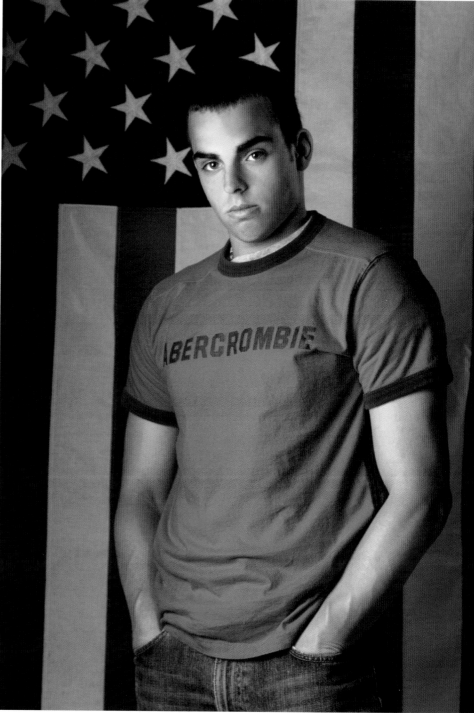

Above—Ralph Mendez' studio sends out attractive "gallery-type" 5x7-inch postcards as a reminder to seniors who have not, as yet, scheduled their senior sitting. By incorporating a wide range of styles, Mendez reinforces his studio's great diversity. **Right**—This handsome portrait by Ralph Romaguera Photography emphasizes the senior boy's strong arms and rugged good looks. The posing is very casual, yet the photographer used terrific soft lighting and strong masculine posing to make it an effective portrait.

the color sections of the yearbook (in which the senior pictures are found) completed and ready to send to the yearbook company shortly after the beginning of the school year. This usually means all portraits should be taken the summer before the start of the student's senior year.

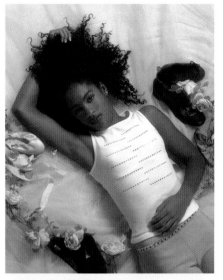

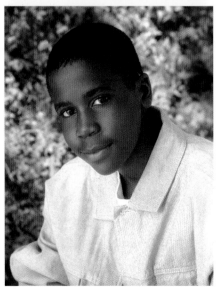

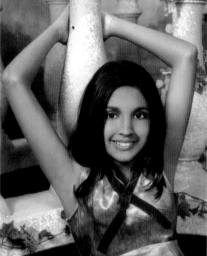

Some seniors only want to take their yearbook portraits in summer and finish their sessions later in their senior year. With most senior studios, this can be done at no additional cost. It merely involves "splitting the session" on two dates.

Since many times missed deadlines are blamed on ignorance (the old "the dog ate my homework" philosophy), the smart senior studio will inform their list of seniors well in advance of upcoming yearbook dates—usually midway through the student's junior year. Reminders are mailed several times throughout this liberal timeline to prevent anyone from missing their deadlines. Schools may often be persuaded to hand out reminder slips to students coming up on their yearbook photo deadlines.

When Contracts Work

Most aggressive senior-oriented studios have decided that contracts, unless they fall in your lap and don't cost you more than you can afford, are a total waste if time. Instead, the studio goes after the students direct-

These portraits are from a series of twelve poses (one roll of 120 film) done for each student by photographers Ira and Sandy Ellis. The job was part of a contract for an upscale prep school in their area. The images were all made either in the studio or in the courtyard leading into the studio. Each student's session would typically take an hour, and each student was instructed to bring their cap and gown, formal attire, props that reflect their hobbies or sports, casual clothes, and their favorite outfits. If they were so inclined, they could even bring along their pet. Since the studio was so close at hand the kids could change in only a few minutes. All of the images included retouching and other minor Photoshop work.

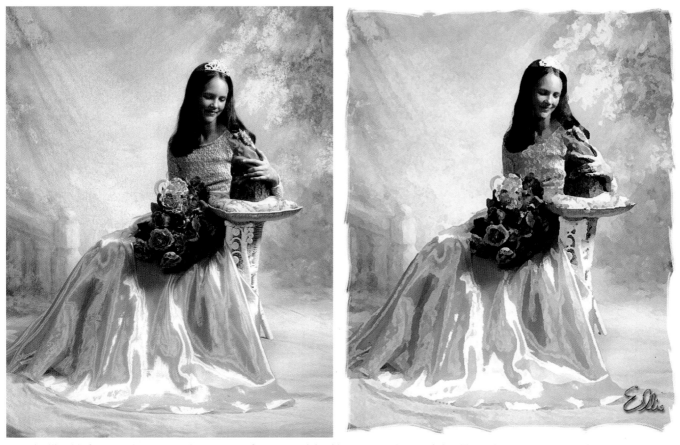

Portraits like this fantasy princess portrait arose out of a contract job. This treatment is one of the Ellis Studio's specialties. The final image (right) was given a watercolor treatment in Photoshop and printed on watercolor paper.

ly, offering superior photography at a reasonable cost.

Most contract studios cannot compete, because they are so used to creating senior images one way—with the same lighting and posing and an assembly-line mentality.

Contracts work when they are small—from fifty to 300 students. Smaller size contracts allow the studio to deliver high-quality sessions with lots of variety. Ira and Sandy Ellis recently accepted a contract for a small private school for the eighth-grade graduating class. The studio delivered their usual diversity—a minimum of twelve poses, several background and outfit changes, some studio shots (including cap and gown shots), and a lot of casual portraits. They offered a beautiful selection to the students and parents, and the average order ranged from $600 to $1,700. There were a few parents who didn't order anything, but by and large, the school loved the images, as did the parents, and for these students, this was the first time many had ever been exposed to a professional photographer since they were small children.

This exposure to quality photography was one of the goals of accepting the small contract. If the families liked the work, then the Ellis studio would reap the benefits of family portraiture, senior photography, and perhaps down the line, even the wedding contract.

Often there are some trade-offs, even to the small contract. You will sometimes be required to provide the yearbook with a black & white or color photo of each student in the graduating class done to the yearbook specs. In exchange, you will receive the up-to-date mailing list of the class, so that you can directly market to them.

Sometimes contracts will require that you provide film and processing to the photography class or photo department, so that they can take candids for the yearbook. Larry Peters, a nationally known senior photographer from Ohio, has had one small contract, for which he agrees to furnish forty rolls of black & white film, processing, and 3½x5-inch prints.

You may have to agree to photograph various activities and sports events, and you may even have to

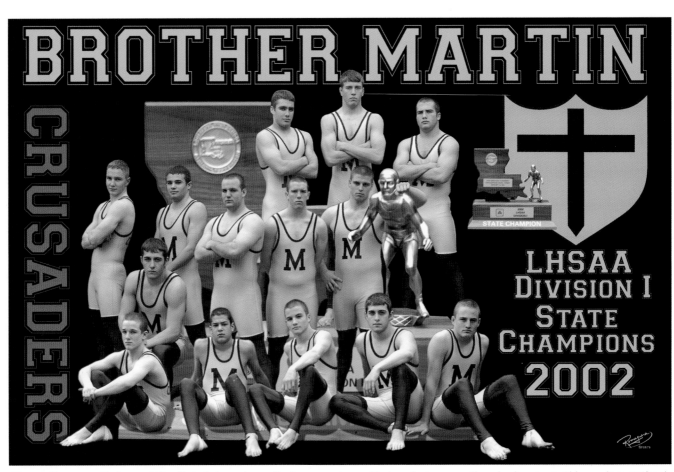

Above—The composite is something that photographers will often agree to provide in order to secure the school contract. This one is exceptional. Made by Ralph Romaguera Photography, the composite features the boys state champion wrestling team and includes their trophy and the school crest. All composite work was done in Photoshop.

specify how many trips to the school and how many events that will entail. The prints, of course, will be free to the school. Popular activities you may have to cover include homecoming, proms, and other major school events. The photographer can, or course, market homecoming or prom photo packages directly to the students to recoup some of the costs.

Smaller schools may require the photographer create a class composite showing all of the students, their names, and the school graphics. Fortunately, this type of thing is easily done in Photoshop, provided the images were created digitally.

Some of the "old-time" contracts require the photographer to loan or even give camera equipment to students. This should be avoided, as any professional equipment you loan out will generally not come back in good condition. Another thing to be avoided is the "rebate" asked for by the school from the profits generated by your senior sessions. This is nothing more than a kickback and should not be tolerated.

Today's Senior Studios

Many studios now offer high-end, very upscale senior sittings that allow the kids to be photographed with their favorite things in their favorite locations. These senior images cater to the kids' sense of self-image and feature the senior's favorite things, places, outfits, and moods. A senior's car—a treasured possession—is usually an important prop included in these sessions.

These are not the senior pictures of even a few years ago. Today's senior pictures have a stylized look and feel and the use of special effects and digital retouching are prerequisites. Today's seniors' sense of what is good photography has become so refined because of their exposure to movies and television that they can't be "conned." As a result, they have become discriminating customers who demand high levels of artistic and technical photography.

In past decades teens were discouraged from expressing their individuality. Today it is something that is encouraged and the smart senior

photographer caters to this notion. Most senior photographers will tell you that the images seniors like the best are the ones in which they "look themselves." That means no phony smiles and very few highly structured poses.

But there are two schools of thought regarding the most popular types of senior portraits. The parents, who invariably pay for the session and prints, have distinct likes and dislikes as well, and while they might tolerate some of the "cool" poses, they probably would like something a little more traditional—something that will stand the test of time. The savvy senior photographer will cater to both groups honestly and will reap the rewards of increased sales.

Why Good Photographers Turn to Seniors

In researching this book, I spoke to quite a few accomplished senior photographers who have migrated to this field from other successful ventures. Some are award-winning wedding photographers who wanted a change or wanted a means of making their studios profitable twelve months a year. Some are successful portrait and children's photographers who simply like the teen age group. But almost all of these photographers agree that the senior age group represents the fastest growing segment of the photographic market, and it is predominantly upscale and high dollars, meaning not only increased profits, but increased prestige within the community.

It's cool to be an in-demand senior photographer. Like the outdated moniker of the "weekend warrior," which referred to the part-time wedding photographer of the past, so the status of the senior photographer has risen from the surly guy who does yearbook photos to a full-service studio with a large staff of employees and hundreds of possible options for customers.

Web Sites

It is almost essential to have a full-service web site if you are in the senior photography business. The

Brian King has a sense of what is cool and what's not. This senior image was made to create a feeling about the person as opposed to creating a literal, descriptive portrait. The image does, however, reveal a lot about the senior girl's personality.

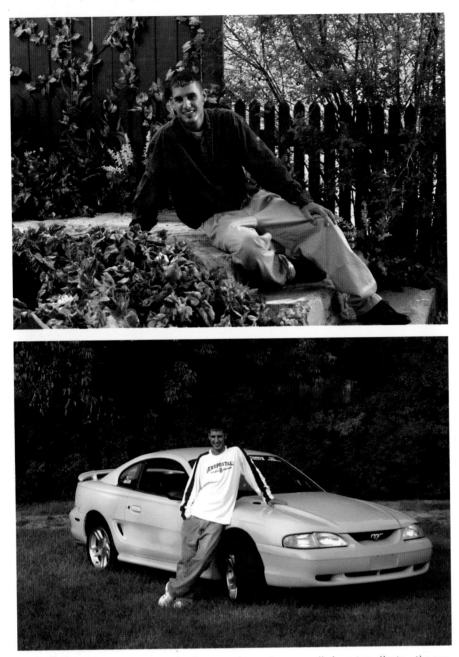

The photographer should be aware that in any senior session you really have two clients—the parents (for which this image would be ideal) and the senior (for which the image of the senior with his Mustang would be ideal). Images by Patrick Rice.

Here are a few samples from Romaguera's FAQ (frequently asked questions) page:

What about zits?

No problem! Our retouching staff will take care of them for you. Don't cancel your appointment because of a small blemish. The retouching is better than benzoyl peroxide!

But I have braces . . .

Our retoucher can even remove braces! There is an extra charge for this service, but it's better than waiting.

What about nails?

Don't forget the importance of your hands in your portraits. Whether you choose to do them yourself or have them manicured, remember to keep the nails clean and neutral in color. We often show feet as well.

Should I get a tan?

Make sure to avoid tan lines, because they will show up in the pictures. They can be removed; however, there is a charge.

Internet has become the equivalent of the library, the Yellow Pages, and the telephone all in one. The Internet is the way young people not only find out about a great many things, but it is also a primary means of communication.

One group of senior studios in the New Orleans area, Romaguera Photography, has created a very hip and informational web site that includes a gallery of the studios' award-winning senior photography. Not only can kids get a feel for the Romagueras' style of photography (Ralph and his two sons, Ralph Jr. and Ryan, are the principal photographers), but they can get answers to every question they might have and then even drop the studio an e-mail with additional questions or a request for an appointment.

The more information you can provide to this age group, the better off you will be. Many teens are reluctant to ask embarrassing questions, such as "What about my complexion?" But if you include all the information they'll need to make an informed decision about your studio, they will more than likely choose your studio for their senior portraits.

*T*ypically, what separates good portraiture from the snapshot is the way in which the subject is posed. Good portraiture renders the face, body, and each portion of the subject's body as pleasing and accurate to the eye, with a minimum of distortion. Many things can cause distortion, such as the camera being too close to the subject and, more frequently, poor posing. By posing the subject's hands facing into the camera, for example, the hands will look unnatural and stubby. If the elbows of the subject are tight to the body, the subject will look blocky and overweight.

The rules of posing and composition offer ways to render subjects in a flattering manner. Posing exists because photography is an imitation of reality. Photography is a two-dimensional recording of a three-dimensional world. There are certain rules and guidelines that will predictably render the human form in a

Deborah Lynn Ferro created this beautiful high-impact portrait that is built around a casual pose using strong diagonal lines. A "Polaroid" type edge treatment and a canvas-like feel to the midtones of the image give it a very contemporary style.

Right—Fuzzy Duenkel created this glamorous and dramatic pose with a very formal character. The formal attire of the senior lends itself to this pose, as does the flowing chiffon, which gives a dreamlike quality to the portrait. Fuzzy combined shallow depth of field and diffusion and grain effects in Photoshop to create the atmosphere. The elegant line of the arms and hands and the very feminine tilt of the head make this image unforgettable. **Facing Page**—This beautiful portrait was created by Larry Peters. Were it not for the curving architecture of the props, the subject would be standing straight up and down in the frame. Instead, Larry had the young woman lean into the curved shape, creating a gently sloping line in her shoulders. In fact, the curved prop roughly mimics the form of the female body. Peters also had his subject put her weight on her back foot, another posing basic. While her head is tilted toward the near shoulder, the direction of her gaze forms yet another pleasing dynamic line within this fine composition.

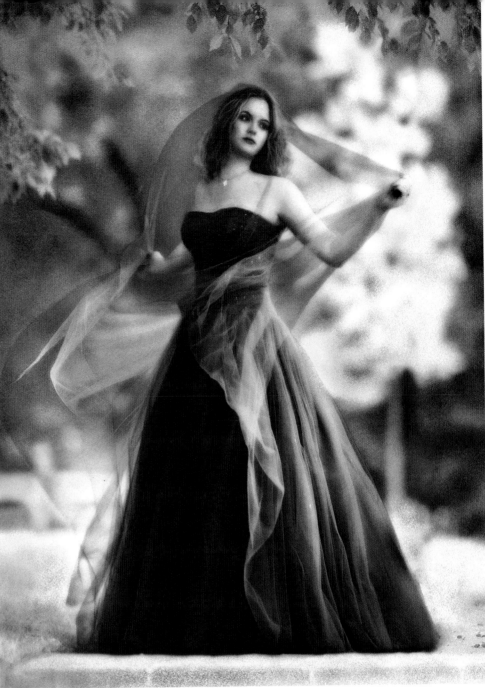

distortion-free, pleasing manner and will create the illusion of three dimensions.

Relaxed, Natural Posing

One of the keys to good senior photography is relaxed, casual posing. Even formal portraits should have a casual feeling to them. Teens and seniors will react poorly to traditional posing, yet some structure is needed or you are no longer in the realm of portraiture. While the guidelines that follow are not meant to be followed rigidly, they do comprise a system of rendering the human form in a flattering way with a minimum of distortion. It is essential, however, with today's seniors to create a system of posing that "looks" natural, yet follows some basic principles of good posing. Good posing doesn't necessarily have to feel good to the subject, but it should appear natural—a pose that the person would fall into naturally. This usually starts with a comfortable seat, even if it's on the floor of the studio. From there, the pose can be modified to make it a professional portrait.

Subject Positioning

As a general rule, it is important not to photograph your subject head-on, shoulders square to the camera. This is the basic mug-shot type of pose, and while it is acceptable in close-up portraits, it is generally

Above—In this portrait by Barbara Rice of her son Travis Hill, Barbara uses very subtle lines to add asymmetry to the pose. The shoulders have a very slight tilt. The head is tilted toward the far shoulder and the crossed arms create two more subtle diagonals. Placing her subject off center in the composition contrasts the uniformity of the background. Left—In this three-tone posterization by Richard Pahl you see some of the essentials of good posing in a head-and-shoulders portrait. The subject's shoulders are at a 45-degree angle to the camera; the angle of the subject's head is at a slightly different angle, thus providing a good head-and-shoulders axis; and the subject's head is tilted toward the far shoulder, a decidedly "masculine" pose.

not recommended. The shoulders should be at an angle to the camera. Positioning any stools, chairs, or other posing devices on an angle to the camera so that when the young person is placed into the scene, the shoulders are already turned to an angle easily does this. This technique introduces a visually pleasing diagonal line into the composition and introduces the illusion of receding form—one part of the body is closer to the camera than another, making the viewer subconsciously realize three-dimensional depth.

The Head and Shoulders
The Head-and-Shoulders Axis. Turning the shoulders is step one in posing. Step two is to turn the head to a slightly different angle than the shoulders, thus introducing a second dynamic line into the composition. With small children, the dynamics of posing are largely a function of luck. Teens, however, can be easily directed, within reason, to satisfy these basic posing requirements. With the angles of the head and shoulders different, even if only slightly different, you have intro-

duced two fundamentals of dynamic posing—the illusion of depth and the creation of dynamic lines within the composition. As a matter of reference, in a bordered, two-dimensional image, the frame edges represent static lines since they are perfectly horizontal or vertical. An interesting composition includes a minimum of static lines and a multitude of dynamic (diagonal) lines, all for the purpose of creating visual interest within the portrait.

Male Posing vs. Female Posing. In traditional male portraiture, the head is more often turned and tilted the same direction as the shoulders, but with women, the head is often tilted toward the near shoulder. The only reason this is mentioned here is so that you will be aware of the difference.

While this view of male versus female posing is somewhat antiquated and by all means not a steadfast rule, it is, nevertheless, followed in many circles, most notably in traditional formal portraiture.

Tilting the Head. A third dynamic in the posing sequence is the up and down tilt of the head. Tilting the head toward the near shoulder, as mentioned above, creates the classic "female pose." Tilting the head toward the far shoulder creates the classic "male pose." However, tilting the head up or down creates a new set of dynamics. Tilt the head up and, depending on the camera height, more of the subject's neck and jaw is visible. Tilt the head down (lowering the chin) and more of the eyes and cheekbones become visible. With this type of

posing, it is a matter of subtlety—don't ask your subject to look at the ceiling, unless you specifically want a portrait of his or her neck. It is a good technique to study your subject's face—either in a pre-session meeting (which is always an excellent idea with kids of this age group), or when they arrive at your studio for the session. As a portrait photographer, you are an expert at analyzing facial features and should know how best to render them with a camera and lens.

Sloping Line of the Shoulders. Whether the subject is seated or standing, a fundamental element of the portrait is the line of the shoulders. One shoulder should always be higher than the other. The line of the shoulders should not be parallel

to the ground. This may be achieved in any number of ways. For instance, in a standing portrait, simply instructing your subject to place his or her weight on their back foot will create a gently sloping shoulder line. In a seated head-and-shoulders portrait, simply having the subject lean forward from the waist will create a sloping line to the shoulders, provided that the person is posed at an angle to the camera.

Face Positions

There are three basic face positions in portrait photography. They dictate how much of the face is seen by the camera.

Seven-Eighths View. The seven-eighths view is when the subject is looking slightly away from the cam-

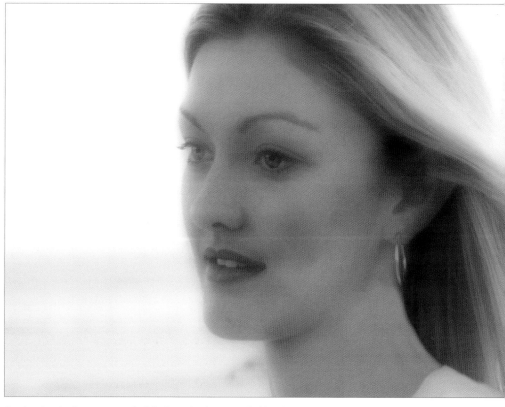

In the classic three-quarter facial view, the far ear is hidden from camera's view. In this elegant pose by Richard Pahl, the subject is getting very close to a profile pose. If she were to turn her head only a few more degrees, the far eye would begin to disappear behind the bridge of her nose. This image is called *I Get Misty*.

era. From the camera position, you will see slightly more of one side of the face than the other in the seven-eighths view. You will still see the subject's far ear in this pose.

Three-Quarters View. With a three-quarters view, the far ear is hidden from the camera and more of one side of the face is visible. The far eye will appear smaller because it is naturally farther away from the camera than the near eye. It is therefore important to position the subject so that his or her smallest eye (people always have one eye that is slightly smaller than the other) is closest to

This elegant portrait by Fuzzy Duenkel has amazing depth and dimension, created by the lighting and the pose. The pose is three-quarter facial view with a camera height slightly below her eye level so that you can see into her eyes as she gazes downward.

the camera, thus making both eyes appear uniform in size.

Sometimes the three-quarters view is referred to as the two-thirds facial view. Many photographers have reminded me of this. However, this is the way I learned about posing, and it makes sense to differentiate the seven-eighths view from the three-quarter view so that there is a subtle difference in facial poses.

Profile View. In the profile pose, the head is turned almost 90 degrees to the camera. Only one eye is visible. In posing your subject in profile, instruct the subject to look gradually away from camera position. When the far eye disappears, your subject is in profile.

With all three of these head poses, the shoulders should remain at an angle to the camera.

The Eyes

It is imperative that the eyes be the focal point of any portrait. With teens and seniors, there is a great deal of their character visible in their eyes, primarily because they are not yet adept at all of the subterfuge and masking of emotions that go with being an adult.

The best way to keep anyone's eyes active and alive is to engage him or her in conversation. If the senior does not look at you when you are talking, he or she is either uncomfortable or shy. In extreme cases you may decide to throw on one of their CDs on your sound system and be quiet. Let the music stimulate his or her imagination, which will cause them to relax.

The direction of the gaze is also important. Start the session by hav-

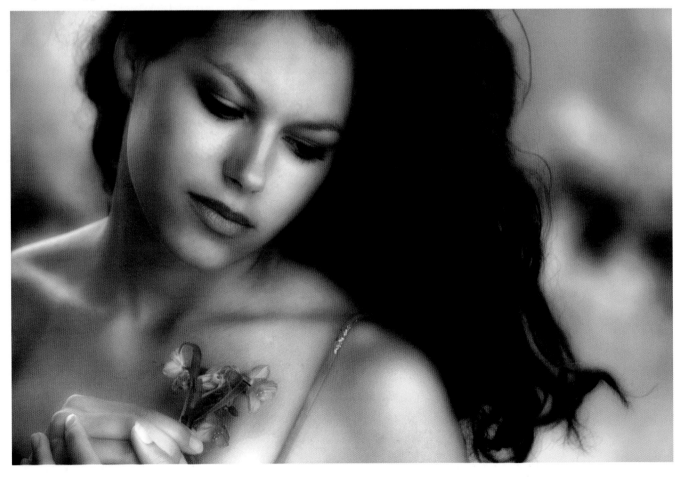

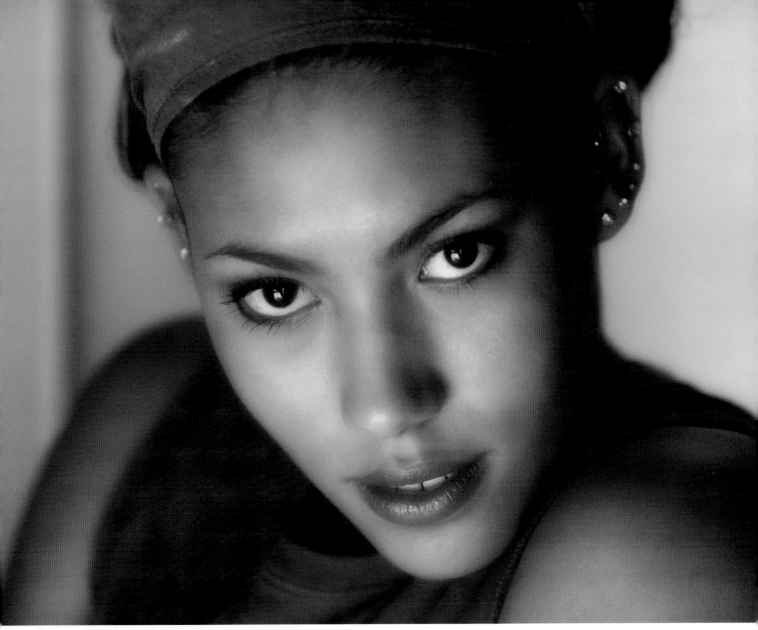

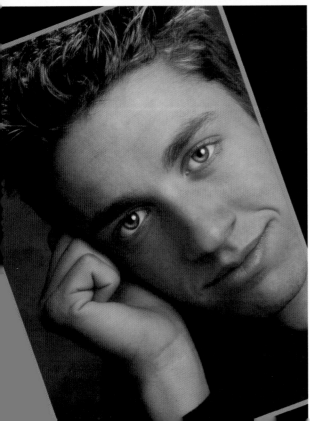

Above—This portrait by Fuzzy Duenkel is all about this young lady's eyes. Fuzzy used diffused daylight as his main light source and several reflectors—all of which show up as catchlights reflected in her eyes. His camera was positioned at eye level, and he directed her to drop her chin and look directly into the camera, providing a little white space beneath the iris of the eyes. The result is a very confident and beautiful look. **Left**—In this handsome portrait by Frank Frost, the "subject" is primarily the boy's green eyes. Frank used a head-on pose, usually not recommended, but tilted the image within the print frame to produce dynamic lines. Frost diffused the catchlights in the eyes, which you can see are in the shape of an umbrella. Also, he had the young man place something in his hand to give it slightly more dimension than a clenched fist.

Left—The ultimate reward is when the subject's eyes smile, as in this senior portrait by Norman Phillips. This usually happens when the person is absorbed in something you are saying and it is a full, genuine reaction. **Right**—Not all portraits have to be smiling. In fact, a pleasant pose that offers a hint of a smile can be much more appealing. In this handsome portrait by Frank Frost, the subject's expression is relaxed. Note how well the hands are posed—there is separation between the fingers to show depth, and there is good definition in the shape of the hands because of the expert lighting, which skims the surface of the subject's hands.

ing your subject look at you. The colored part of the eye, the iris, should border the eyelids. In other words, there should not be a white space between the top or bottom of the iris and the eyelid. If there is a space, redirect the subject's gaze. If working with a cable release or radio remote, you can simply move slightly to the left or right of camera and continue your conversation.

Pupil size is also important. If working under bright modeling lights, the pupils will contract. A way to correct this is to lessen the intensity of the modeling lights. You can always increase the intensity to check the lighting pattern and quality before you actually begin making portraits.

Just the opposite can happen if you are working in subdued light. The pupils will dilate, giving the young person a vacant "not at home" look.

The Mouth

It is always a good idea to shoot a variety of portraits, some smiling, some serious, or at least not smiling. People are most self-conscious about their teeth and mouths. If you see that the subject has an attractive smile, make lots of exposures of the person smiling.

One of the best ways to produce a natural smile is to praise your subject. Tell him or her how good they look and how much you like a certain feature of theirs. Simply to say "smile" will produce a lifeless, "say cheese" type of portrait. With sincere confidence building and flattery you will get the person to smile naturally and sincerely, and their eyes will be animated.

Pay close attention to the mouth to be sure there is no tension in the muscles around it, since this will give the portrait an unnatural, posed look. An air of relaxation best relieves tension, so talk to the person to take his mind off the session.

Some people have a slight gap between their lips when they are relaxed. Their mouth is neither open nor closed but somewhere in between. If you observe this, adjust your posing instructions accordingly. Tell the person to smile and then suggest a more serious pose. If the mouth is slightly open in the serious pose say, "Maybe a little more serious . . . " or something along those lines. Because you are freezing a moment of time in a portrait, the gap between the lips will look most unnatural because teeth show through the gap. When observing

the person in repose, this trait is obviously not so disconcerting as it is when it is frozen pictorially.

Posing Hands and Fingers

Posing hands can be very difficult because in most portraits they are closer to the camera than the subject's head, and may appear larger. One thing that will give hands a more natural perspective is to use a longer lens than normal. Although

holding the focus of both hands and face is more difficult with a longer focal length lens, the size relationship between them will appear more natural. And if the hands are slightly out of focus, it is not as critical as when the eyes or face are soft.

The nice thing about photographing a teen's hands is that they are not nearly fully developed and as a rule are smaller than adult hands.

One basic rule is never to photograph a subject's hands pointing straight into the camera lens. This distorts the size and shape of the hands. Always have the hands at an angle to the lens. Another basic is to photograph the outer edge of the

Below—Keeping hands in the same relative plane as the face prevents them from appearing overly large as a result of being closer to the camera. Although only one hand is visible, it is posed beautifully, with slight separation between the fingers and the curving edge of the hand wrapping around the pillow. **Right**—Here, the senior's hands are kept in the same plane as her face for adequate perspective but also to be able to hold focus on both her hands and her face. The tilt of her head introduces a beautiful line in the composition that contrasts the many true horizontals and verticals. Both portraits are by Frank Frost.

Facing Page—In this lovely formal portrait by Larry Peters, the young woman's hands, with their exceptionally long fingers, seem to be the focal point of the composition. Peters posed her hands elegantly with a nice break to each wrist and plenty of separation between the fingers. The long diagonal line of her arms and fingers balances the diagonal line of the drape above, creating a perfect sense of balance.

Right—Seated, full-length poses are very tricky to accomplish. Here Brian King handled the pose to perfection. The subject is sitting forward in the chair, her back upright and away from the back of the chair, creating excellent posture. The girl's casually crossed legs create a beautiful line that leads your eye up to her face. The hands are posed nicely on the edges and her arms are at a distance from her torso, creating a comfortable yet fluid pose. Beyond the wonderful posing, the selective soft focus and high-key nature of the window lighting make this a gorgeous portrait. Brian diffused the portrait selectively in Photoshop and raised the "key" of the image by adjusting tones toward the highlights.

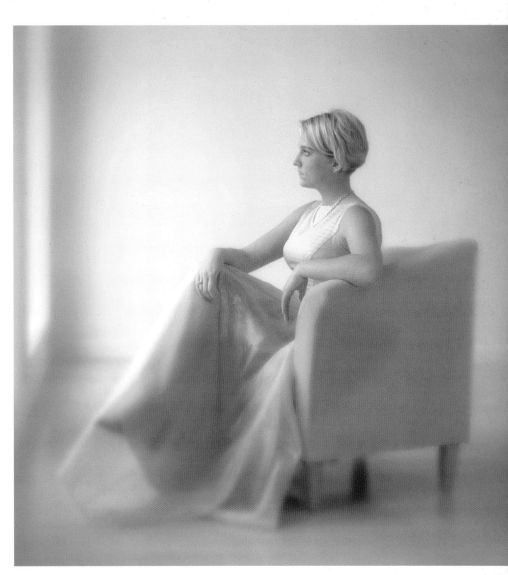

hand when possible. This gives a natural, flowing line to the hand and eliminates the distortion that occurs when the hand is photographed from the top or from head-on.

Always try to "break" the wrist, meaning to raise the wrist slightly so there is a smooth bend and gently curving line where the wrist and hand join.

You should also try to photograph the fingers with a slight separation between each digit—especially with girls who pride themselves on their long, slender fingers. A slight separation gives each finger some individual form and definition. When they are closed together, they tend to look like a two-dimensional blob.

When photographing a young man's closed hand it is a good idea to give him something small, like the top of a pen, to wrap his fingers around. This gives roundness and dimension to the hand so that it doesn't resemble a clenched fist.

As generalizations go, it is important that female hands have grace and male hands have strength.

The placement of hands is very important and can be key to an effective portrait. Flat hands are unattractive. Fingers turned in on a flat hand can look like claws. Be sure to have the subjects extend their fingers so that they are long and graceful, with the edge of the hands toward the camera. Assure the sitter that what may seem or feel awkward to them comes across as quite natural from the camera's viewpoint.

Knowing how to pose hands effectively is something that separates the expert portrait photographer from the average one. It is an acquired art that requires practice and observation to perfect.

Three-Quarter and Full-Length Poses
A full-length portrait shows the subject from head to toe. A full-length portrait can show the person standing or sitting, but it is important to

Top Left—In this three-quarter-length portrait by Deborah Lynn Ferro, the line of the shoulders and right arm are parallel to the horizontal print edge—usually not recommended. However, Deborah created an elegant flowing line of the body that overpowers these horizontals for a dynamic pose. Notice how the subject's arms are separated from her torso by enough space to give them dimension and also so that you can see her slender waist. **Bottom Left**—In this composite of Allison, Larry Peters combined six full-length poses—all of them dynamic and all of them form-flattering. No doubt this senior was happy with this composite of images. **Right**—In this three-quarter-length portrait, Ralph Mendez cropped the bottom edge at just the right location—between the ankles and the knees.

remember to angle the person to the lens or adjust your camera position so that you are photographing him or her from a slight angle. The feet should never point into the camera lens, but should be at an angle. This is an aspect of full-length portraiture that is easy to overlook.

A three-quarter-length portrait shows the subject from the head down to a region below the waist—usually mid-thigh or a point below the knee and above the ankles. In three-quarter-length poses (those that don't show the entire body), never "break" the composition at a joint—at the ankles, knees, or elbows. It can be visually disturbing.

The difference between a three-quarter-length and full-length pose may not seem like much, but it is, primarily because in a full-length pose one must include the feet of the subject. Often, adolescents' feet are big, and they photograph large as well. Additionally, more than any article of clothing, shoes date a photograph; it is best, most times, to avoid full-length poses unless there is a way to disguise the feet. Often

photographers conscious of the problems that feet create will have their teenage subjects go barefoot, thus minimizing the problems.

In full- and three-quarter-length poses hands also become a real problem. If you are photographing a guy, have him stuff his hands in his pockets—thumbs out. It's often an endearing pose. You can also have him fold his arms, although teens sometimes adopt a defiant stance in this pose. With a teen girl, have her put one hand on her hip, making sure you can see her fingers.

Weight on the Back Foot. The subject's body should be positioned at a 30–45-degree angle to the camera. Weight should always be placed on the back foot, rather than being distributed evenly on both feet or, worse yet, on the front foot. There should be a slight bend in the front knee if the person is standing. This helps break up the static line of a straight leg. If the subject is female and wearing a dress, a bend in the front knee will help create a better line to the dress. The back leg can remain straightened, since it is much less noticeable than the front leg.

Camera Height

Camera height can drastically affect subject perspective. For head-and-shoulders portraits, camera height should be mid-face or around nose height. Using too high a camera position will narrow the subject's cheeks and chin. Using too high a position will distort the shape of the person's head. It may also cause you to see too much of the top of the head.

This holds true for three-quarter-length and full-length poses as well. Camera height, especially with shorter focal length lenses, should be midway between the top and bottom of the person's body.

If you follow these rules of perspective, you will not intentionally distort your subject's features, provided you are working at a decent camera-to-subject distance.

The principle of camera perspective works like this: the points in the photo that are the farthest from the camera look the smallest. Therefore, if photographing a full-length portrait from nose height, for example, the feet will be much farther from the camera than the subject's face and consequently will look very small.

Working Distances and Focal Length

Just as important as camera height is camera-to-subject distance and the focal length of the lens. For three-quarter- or full-length portraits, it is advisable to use the normal focal-length lens for your camera. This lens will provide normal perspective because you are farther away from your subject than when making a head-and-shoulders portrait.

The rule of thumb for selecting an adequate portrait lens is to choose one that is twice the diagonal of the film you are using. For example, with the 35mm format, usually 75 to 85mm is a good choice; for the $2\frac{1}{4}$-inch square format (6x6cm), 100 to 120mm is fine, and for $2\frac{1}{4}$x$2\frac{3}{4}$-inch cameras (6x7cm), 110 to 135mm is advised.

Fuzzy Duenkel used an 80–200mm f/2.8 lens at the 135mm setting (at f/4) for good perspective and to soften the muted colors of the background. The image is backlit with late afternoon golden sunlight and filled from the front with reflectors. You will notice that when using longer-than-normal focal length lenses in portraiture, proper size perspective is maintained—her hand looks "correct" in relation to her face. Fuzzy also used slight diffusion in Photoshop—Gaussian blur—to lower the overall contrast and soften the colors.

Tim Kelly's *The Debutante* is a pose that was captured between frames as the young lady relaxed and Kelly changed film magazines. Tim does not like to offer posing suggestions so much as to let the subject fall into a pose they feel themselves in. This is an award-winning image.

This longer-than-normal focal length provides an adequate working distance so that close-up portraits can be made without distorting the subject's features. With a "normal" lens on the camera, you would be forced to work too close to the subject to produce an adequate image size on the film plane. This is particularly true with head-and-shoulders portraits made with a normal lens, in which the nose will appear elongated, the chin will often jut out, and the back of the subject's head may appear to recede. The closest facial features, like the nose, will appear enlarged, while those features farther away, like the ears, will appear smaller. These effects are a result of perspective and working too close to the subject.

The short telephoto lens provides a greater working distance between camera and subject with increased subject magnification so that all planes of the face appear to be at the same relative distance from the camera, thus providing a more normal and desirable perspective.

You can use a much longer lens if you have the working room. A 200mm lens, for instance, is a beautiful portrait lens in the 35mm format because it provides very shallow depth of field and allows the background to fall completely out of

focus, providing a backdrop that won't distract from the subject. When used at wide-open apertures, this focal length provides a very shallow band of focus that can be used to accentuate just the eyes, for instance, or just the frontal planes of the subject's face. Or it can be used to selectively throw certain regions of the face out of focus intentionally. Fuzzy Duenkel, a well-known senior photographer, often uses long telephoto zooms to "blast" the background out of focus, creating a muted pastel background so that all visual attention is focused on the subject.

Active Posing

One of the hallmarks of senior photography is what is called "active posing," which is a sort of stop-action glamour posing—isolating the pose from within a flowing movement. This type of posing is useful in photographing trained models, but can also be fun to use with teens and seniors, who can be coaxed into moving quite well in front of the camera. Playing their favorite music helps to set the mood as does keeping the energy level of the portrait session high. You will see many examples of great active posing throughout this book.

Giving Directions

There are a number of ways to give posing instructions. You can tell your subjects what you want them to do, gently move them into position, or show them the pose you are describing. The latter is perhaps the most effective means of communi-

cating with your seniors, as it breaks down barriers of self-consciousness on both sides of the camera.

Subject Comfort

The person must be made to be comfortable. A subject who is uncomfortable will most likely look uncomfortable in the photos. After all, these are normal people, not models who make their living posing professionally.

Pose your subject naturally—a pose that feels good to the subject. If the person is to look natural and relaxed, then the pose must be not only natural to them, but also typical; something they do all the time.

Refinements are your job—the turn of a wrist, weight on the back foot, the angle of the body away from the camera—but the pose itself must be representative of the person posing.

Most times you will be posing your subjects in casual poses, which are basically resting poses. The arms rest on the legs, heads rest on hands. Pay attention to how your subject moves, sits, and stands, and it will give you some clues as to how to best pose them.

Applying and Breaking the Rules of Posing

The above posing rules are simply guidelines that pros should have in

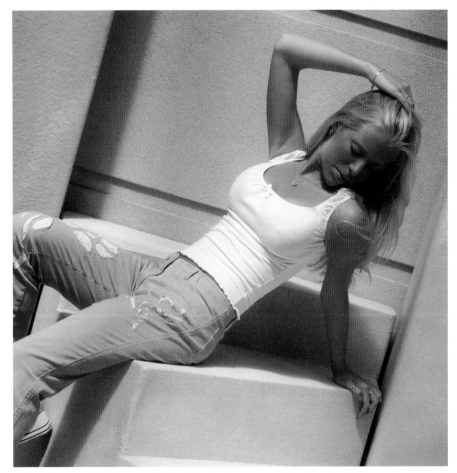

Brian King created this geometrically pleasing three-quarter-length portrait. The pose uses complementary triangle shapes (the line of her right knee and right elbow) and opposing diagonal lines (the line of her body and the line of her gaze leading down her left arm) to create a sense of tension and balance.

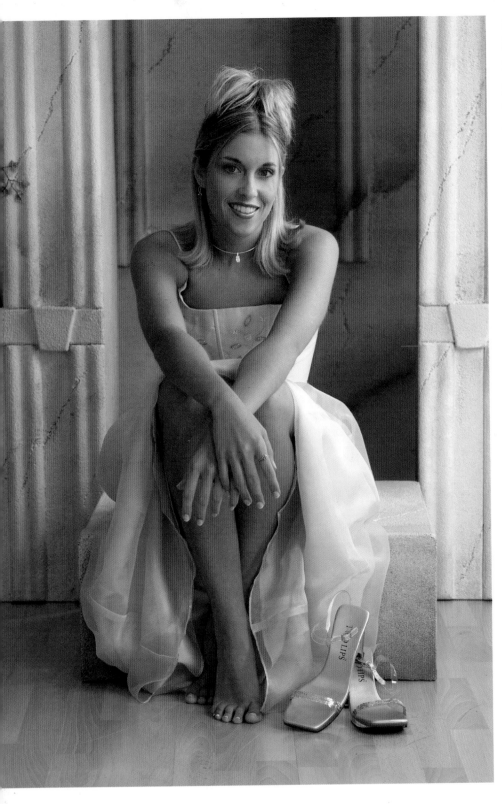

their arsenal of techniques, regardless of whether they photograph teens, babies, or adults. How much you use these guidelines is a function of your tastes and your customers' likes and dislikes.

You will notice that in many of the seemingly casual poses in this book you will find good posing techniques at work. Many of these guidelines are followed in general terms because they lead to a flattering likeness and they enhance the illusion of three dimensions in a two-dimensional medium. Once mastered, many of these techniques become second nature, allowing the photographer to relax the form of the posing and create more casual, elegant portraits with just the flavor of formality.

When you know the rules of posing and composition you may break them all—as Larry Peters has done here. Alicia is facing the camera, shoulders square, and both hands and feet are facing into the camera. Why does this pose work, when it shouldn't? It works because the subject's arms and legs are slender, and the focal length lens used is long enough that the hands don't become huge in comparison to her face. Although Alicia is seated, Peters has her on tippy-toes, shaping her calves and keeping her knees up so the weight of her legs is off her thighs. Her hands do not appear "blobby" because of the side lighting and because there is ample separation between her fingers.

COMMUNICATING AND GETTING GREAT EXPRESSIONS

Parents are often amazed when they see their senior's portraits. Often they cannot get over the range of expressions—the many different sides of their child's personality—that are brought out in a relatively short photo session. It is no accident that great expressions and great poses go hand in hand. But it's not by magic that great expressions happen. As the old coach's saying goes, "Good luck is the residue of design." And so it is here too.

Pre-Session Consultation

The best way to lay the groundwork for good communication is with a pre-session consultation that should include the teen and

Red on red on red—but no red lipstick . . . that would have been too much. Rick Pahl created this delightful portrait in red and white by previsualizing the result and then executing it. The real key to its success is how relaxed his subject is. She is genuinely enjoying her session. The red background was created in Photoshop.

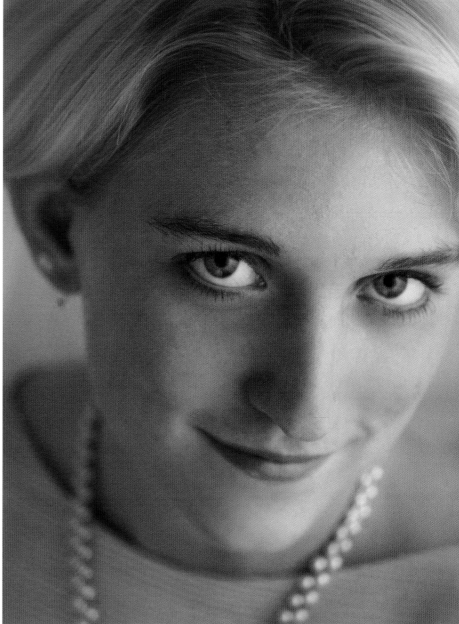

Above—Ellie Vayo does more than get some business out of the way with her pre-portrait consultation session—she also gets to know the senior. When it comes time for the portrait session, Ellie is already acquainted with the senior and can put him or her at ease that much more quickly. **Right**—Brian King is an expert at creating images that are appreciated by both parents and seniors. In this very close-up senior portrait, the depth of field is so slim, it barely extends from the tip of her nose to her eyes. Yet what is important that isn't in focus? And Brian has gotten his subject to smile one of those enigmatic, unforgettable smiles. The secret to great portraiture is unearthing hidden personality.

his or her parents. It can be a short, fifteen-minute meeting, but it does a lot to put everyone on the same page.

Ellie Vayo, a highly respected senior photographer from Ohio, believes in the pre-session consultation meeting, which she calls the "personal pre-portrait design consultation." At this meeting, clothing, location, and the portrait styles the client likes best will be discussed. Ellie encourages seniors to stop by to visit her studio. She tells them

(via her web site) "During your visit, we will give you a free 'Senior' T-shirt! We will also give you a tour of the studio, tell you about prices, and answer any questions you might have. Come in for a tour in April, May, or June and we will give you a certificate for eight free wallets (some restrictions apply), even if you schedule your appointment for July or August!"

According to Jeff Smith, "Many times ideas are not conveyed from the senior to the studio/photogra-

pher about a parent's wishes. For this reason, it is usually a good idea for one parent to come in with their senior." Have the senior and parent go through the samples together, stating what they like and don't like and you will soon begin to form a consensus of exactly what the session should cover. You can show the parents examples of full-length and three-quarter-length portraits and show them the range of different portrait types available. You can talk about the style of clothing, which is

always an issue, and encourage the parent to talk about the things that, to them, are unacceptable. Jeff Smith notes, for example, "a strong dislike by parents of guys is white undershirts showing under a polo shirt or when a dress shirt is worn without a tie and white socks showing with darker pants. For parents, no-nos for girls include tops that end just above the waistline, showing a portion of the midriff and dresses that are too short or low cut." You can also talk about retouching—what it is and how much retouching is covered in the basic session price. Teens are very self-conscious about their complexions and may not bring retouching up, but be assured, it is on their minds.

Two Clients . . . Always

It is always good to keep in mind that you have two clients to please in any senior session—the person in the pictures and the person paying for the pictures. So you have to produce a variety of images that satisfy both parties. Most photographers will opt for the "let's do a couple for your mom and dad" philosophy so that the teen is a willing participant in the process. Parents will want a somewhat traditional senior portrait to send to other family members or to display in the home, and it will be decidedly different from the portrait that the young person likes the best.

One extremely successful senior photographer, Larry Peters, calls his pre-session consultation a "color analysis session," wherein studio personnel help the students decide what colors are best for them to be photographed in. According to Peters, "this added attention to detail shows that we care about their photo sessions and it drives home the point that the photographs I make of them will be outstanding in every way."

Larry Peters continues (on his web site): "We strongly recommend that you come in to one of our studios for a pre-appointment consultation." (Peters even offers a discount on the sitting fee for coming in for this meeting.) He continues, "We encourage your input in your photography session and feel that this appointment gives us the opportunity to discuss ideas you may have. This allows us to use our creative talents to put your ideas into a portrait.

Clothing suggestions, locations, and creative ideas are discussed at this appointment as well."

No Parent at Session

Even though the parents should be part of the pre-session consultation, teens usually won't feel comfortable with a parent around during the photography session. Ask the teen, instead, to bring along a friend or two and photograph them together. Parents often make their own teens feel self-conscious and awkward— the last thing you need when you are making their portrait. You need to assure the parents that you have their best interests at heart and that you want to be able to provide them with a photograph that will make them happy and proud.

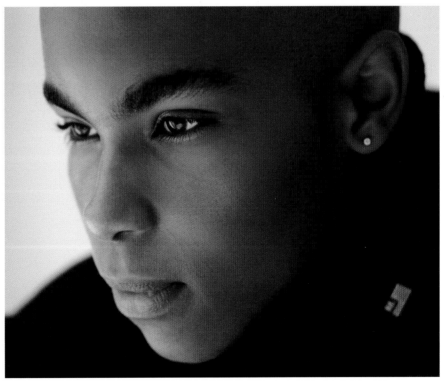

Brian King loves to move in close and isolate his subject. Here he crops out everything over the eyebrows, choosing to isolate the eyes and frontal planes of the young man's face. He does minimal retouching—a little on large pores, blemishes, and creases, but little else, allowing, instead, the character of the person to come through. This is a powerful portrait of the young man that I am sure both he and his parents thoroughly enjoy.

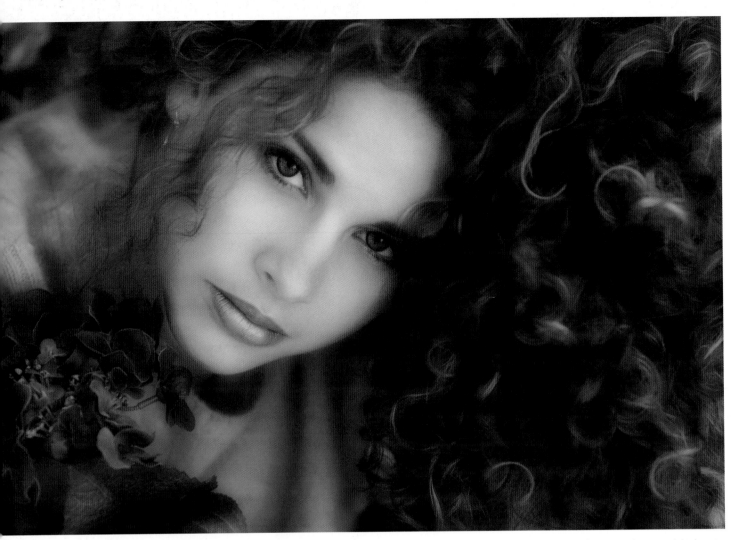

Above—Fuzzy Duenkel decided the attributes of this senior he wanted to highlight were her hair and her eyes, so he composed a very tight beauty shot illuminated by reflected daylight. Subtle makeup was applied before the photo session at Duenkel's studio. Expert color coordination and the introduction of the purple flowers make this a masterpiece. **Facing Page**—Brian King created this intense portrait in which one eye is intentionally hidden and one eye is looking away. Is he angry or is he focused? This is where giving the client what he or she wants becomes the important ingredient in senior portraiture. This portrait could not have been made without some discussion as to what the senior wanted for his portrait.

You can encourage kids to bring in their favorite things, including pets. This will help reveal their personalities even more, and like small children, the presence of their favorite things will help them feel relaxed and at home.

Number and Type of Poses

The pre-session consultation will also define what the senior gets for his or her parent's money. Most photographers will outline what the basic session fee covers and what the basic cost of prints is. There should be no misunderstanding about session fees or reprint costs.

From the photographer's point of view, the most important aspect of senior photography is to show the many different aspects of the senior's personality. Show their fun side, their serious side, the activities they enjoy, and the clothing they like to wear. Typically, a good senior photographer will shoot twenty or so different poses with at least three clothing changes. Clothing selec-

tions should include something dressy (like a prom gown or suit and tie), a casual outfit, a "cool" outfit (i.e., their favorite outfit), an activity outfit (baseball jersey or cheerleader's sweater or letter jacket), and the cap and gown shot (depending on the school and its graduation garb).

Individuality

Gary Fagan, an award-winning photographer from Iowa, pays special attention to the differences between

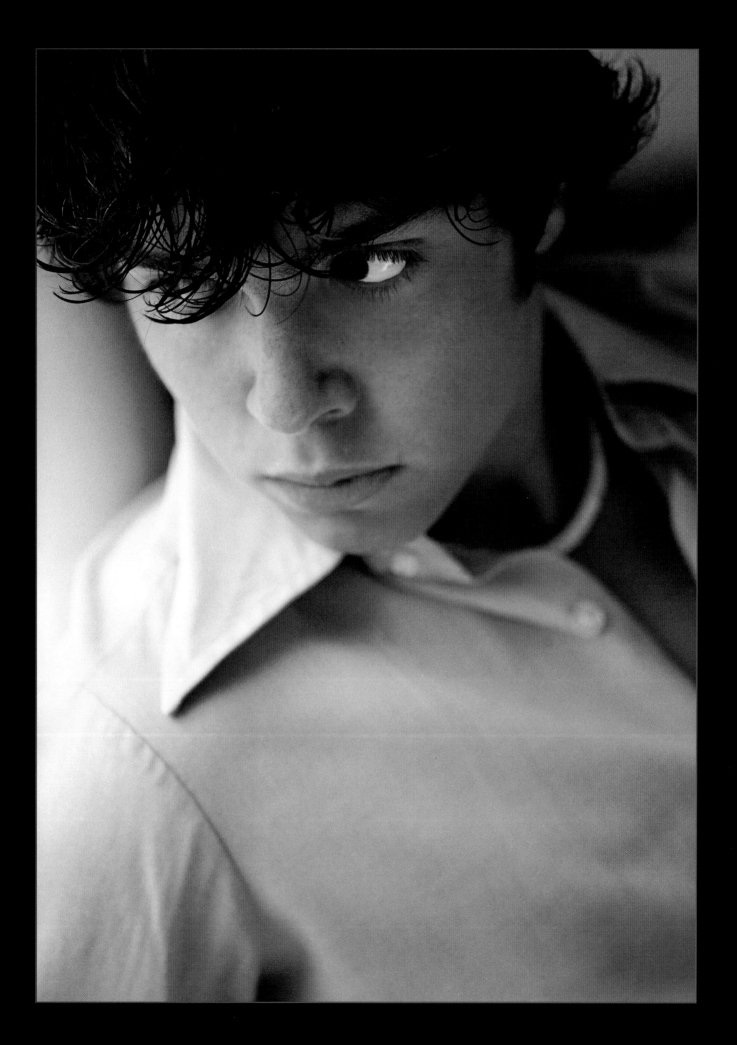

Because Fuzzy Duenkel photographs most of his seniors at their homes or around their homes, he has access to all of their favorite things and their entire wardrobe. Here, he combined clothes the same color as this girl's guitar and hair for a beautiful, color-coordinated portrait. The light here is diffused daylight with reflectors. The portrait was made even warmer in tone in Photoshop.

whatever they wish to make this their personal session."

Facial Analysis

The expert portrait photographer should be able to analyze a subject's face and body language with a brief examination, typically done at the pre-session consultation. You can make these observations while conversing with the teen and, if you are subtle, they probably won't even know you're doing it. Observe the mannerisms and expressions of your subject. Take notes as to poses that they may fall into naturally. Observe how they carry themselves and their posture. You can then use this information in the photo session as you recall (from your notes) a certain pose they fall into naturally. Such insights are a superb icebreaker at the photo session, since you will make them feel that you must know them or at least have noticed them in detail—always a confidence builder.

Examine the person from straight on and gradually move to the right to examine one side of the face from an angle, and then repeat on the left side. Examine both sides from full face to profile. In your analysis, you are looking for a number things:

1. The most flattering angle from which to photograph the person. It will usually be at the seven-eighths or three-quarter facial view, as opposed to head-on or in profile.
2. A difference in eye size. Most people have different size eyes. Both eyes can be made to look

seniors. He says, "My philosophy on senior photography is to treat each client as a special individual with likes and dislikes of their own." He corresponds with them prior to the session to find out their special interests and future plans. He tries to find out as much as he can about each senior so he can communicate with them to make them feel at ease. He says, "I suggest the clothing; however, they are welcome to bring

the same size by positioning the smaller eye closest to the lens so that natural perspective takes over, and the larger eye looks equal in size because it is farther from the lens.

3. You will notice the face's shape and character change as you move around and to the side of your subject. Watch the cheekbones become more or less prominent from different angles. High and/or pronounced cheekbones are a flattering feature in males or females.

4. Look for features to change: a square jawline may be softened when viewed from one angle or height; a round face may appear more oval-shaped and flattering from a different angle; a slim face may seem wider and healthier when viewed from head on, and so forth.

5. Examine all aspects of the face in detail and determine the most pleasing angle from which to view the person. Through conversation, determine which expression best modifies that angle—a smile, a half-smile, no smile, head up, head down, etc.

6. As you examine the facial structure of your subject, examine the complexion as well. If extensive retouching must be done, then you will want to minimize that labor with soft lighting and possibly on-camera diffusion.

Psychology

Seniors want to be different, but not too different from other seniors. The main difference between photographing seniors and adults or small kids is that to be successful, you must cater to those differences.

Seniors are at a crossroads in their lives. They are all at once either leaving home, or going off to college, or they have serious girlfriends or boyfriends, and above all, they may not feel too secure about any aspect of their lives. Their portraits and portrait sessions are an important step in their lives because it represents a sort of mission statement about who they are. While these things are going on in the background, the most successful senior sessions will be interactive and above all, fun. As the photographer, you should have fun yourself. Seniors will tap into your excitement if you let it show. It will help minimize awkward moments.

If you have an open mind and like this age group, you will not prejudge them by their appearance or attitude. They are struggling with the emergence of personality and uniqueness, and much of what you see is an exercise in self-discovery. So don't be put off by piercings, crazy hair, or clothes you wouldn't wear to change your oil . . . none of these things determine how he or she will value your portraits.

It pays to flatter your subject with honest, realistic praise. It should be appropriate and in the right form. Flattery can take the form of your own enthusiasm for the photo session; however, it should not be excessive, or it won't be believed. Part of your job is to make your subjects feel good about themselves, which can be measured later in the

Not every senior is overflowing with personality and self-confidence. One of Romaguera Photography's unique talents seems to be bringing the best out of their senior clients. This thoroughly delightful composite of Crystal shows five portraits in which there is not even an ounce of self-consciousness. She looks fun and adorable and cute in every pose. There is no accident here—the photographer made her feel free to be herself and she made the most out of every pose.

portraits. It is often said that one of the qulaities of a great portrait photographer is that ability to relate to other people. With teens, a genuine interest in them as people can go a long way.

Here are some tips to follow during the session to improve communication and the quality and animation of your portraits.

1. Avoid long periods of silence, even if you need to concentrate on technical details. Reassure the senior about any concerns they might have.
2. Be positive about their appearance and clothing.
3. Work quickly and keep your poses fresh.
4. Be open to suggestions the senior might propose.
5. Smile a lot so that your subject can see you are enjoying the session—especially after you make an exposure that you think

is a good one. Even introspective (moody) teens will react well to a genuine smile.

Breaking Down Defenses

One of the best icebreakers is music. If you either encourage the senior to bring along some of their own CDs or you have a good selection on hand, you may find that the person has already begun to relax and "get into it" by the time you're ready to make the first exposure.

Most senior-age kids don't want to be photographed like little kids, with big grins. They probably want to look cooler than that, and they may not want to smile at all. Most photographers agree that a pleasant, happy expression is considered more desirable than a big smile. In such a mode, the face is relaxed and people look like themselves. Beware of the "fake smile" as it might show up in anticipation of what they think you want to see. A real smile is quite dif-

ferent than a fake one because it involves the entire face. A fake smile involves just the mouth.

The very best way to get the senior to elicit the smile you want or the look you want is to have earned their trust and for them to be relaxed. If you have had a presession consultation, the barriers of a first meeting are already done with and they will be less self-conscious. Above all, encourage seniors and teens to be themselves.

Create a variety of smiling and non-smiling poses. Everyone will appreciate the variety.

Clothing and Accessories

It is important that seniors choose outfits that they like. They should bring a number of complete outfit changes and include as much variety as possible—some formal, some casual, and some activity-based clothing. Most seniors choose some casual and some dressy outfits.

Left—One of the keys to great senior portraiture is breaking down defenses. Often photographers will tell seniors to bring along a pet or a significant other, knowing that their presence will relax the subject. In this case, Brian King capitalized on this couple's mutual self-confidence and relaxation and was able to create a portrait that is highly intuitive about each person. This insight is heightened by King's propensity for working very close to his subjects, using frame-filling focal lengths. **Right**—The strong color of this image by Frank Frost is what makes it so enticing. Frank chose to seat the girl dressed in her red dress in her shiny red car, obviously a prized possession. Notice the subtle highlight behind her waist that serves to separate her figure from the dark inside of the car—an effect that helps to slim her waistline.

Sweaters work well for senior boys or girls and they allow for quick outfit changes. Blues are an excellent shade for this boy as the tones in the sweater help bring out the pronounced blue of his eyes. Photograph by Deborah Lynn Ferro.

For guys' more traditional portraits, a suit or sport coat with a tie is good. Also, according to Ellie Vayo, medium to dark sweaters photograph well. For casual or outdoor portraits, comfort is the rule—jeans, shirts, sweaters, shorts, sweatshirts, or western wear work well.

For girls, dresses—even prom gowns—sweaters, and lace are recommended for a more traditional look. However, sleeveless outfits and those with very short sleeves should be avoided because upper arms can be very distracting in a portrait. Ellie Vayo tells senior girls, "If you like an outfit, it's probably because you look good in it, so make sure you bring it!"

Colors and Patterns. The color of the clothing should be toned down. Bright colors attract attention away from the face. Prints and any kind of pattern—no matter how small—become a distraction, and in the case of digital portraits, small patterns in clothing may cause moiré patterns to appear in the portrait that were not originally there.

"Casual outfits are best kept to solid colors. Denim, white, black, and solid earth tones almost always look good," says Ralph Romaguera on his senior web site. He also says, "Casual clothing allows you greater variety and better expresses your personality. Things to avoid: stripes, bold patterns, and prints that dis-

tract; neon colors; and clothing with any wording on the front." Romaguera reiterates that clothing should be flattering, but not overpowering.

According to Monte Zucker, one of the finest portrait photographers in America, darker clothing helps to blend bodies with the background, so that faces are the most important part of the photograph. Dark colors tend to slenderize, while light colors seem to add weight, not usually a problem with seniors who tend to be on the slim side anyway.

Jeff Smith, on his web site, reminds students to bring along accessories. "Accessories, like sunglasses, scarves, or hats can give the

portrait a unique look, so bring them if they fit your style. Also, make sure you include any personal props (football, stuffed animals, etc.)." Some photographers, like Ellie Vayo, suggest a checklist so that small things (like matching sunglasses) don't get left at home.

Shoes. Many times seniors will go barefoot—and not just for portraits made at the beach. Sometimes even in full-length portraits subjects want to be photographed barefoot, which is actually a happy accident as shoes tend to date a photo more than any other article of clothing.

Just as seniors will want to bring a change of clothes to their photo sessions, so they should bring different shoes that complement their outfit changes.

Eyeglasses. Seniors who wear glasses may want to do so in their portraits and should borrow a set of empty frames from their optometrist if their glasses tend to create facial distortion. Optometrists will often loan a pair of frames to a customer at no charge. Normal retouching will not necessarily get rid of glare from eyeglasses, nor will it correct the facial distortion caused by the refractive characteristics of certain glasses.

Hair and Makeup

Ellie Vayo's studio sessions begin with a makeup application in which a trained makeup artist applies photographic makeup to the senior girls. The amount and color of the makeup depends on the type of portrait and the outfits selected.

Girls should not have their hair cut too close to the portrait session,

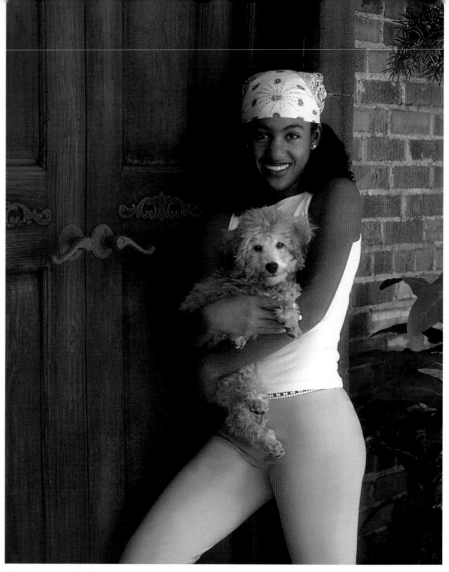

The color coordination in this portrait by Ira Ellis is flawless. The pink tights are the perfect complement to the green door (actually a prop that stays outdoors all year round and weathers). The plants, added for accent, help to balance the overpowering brightness of the pink. Bringing along her pooch made this young lady very happy and it shows in the portrait.

and they should not have it done the day of the session. Hair should have a few days to "relax" after a trip to the beauty salon. If girls have their hair cut or permed a week or so before their session it will give it sufficient time to "fill in." Ellie Vayo warns, "Don't try a radically different haircut or style—chances are you won't feel it expresses the 'real you.' Don't cut it until you have seen your previews."

Hair falling down onto the sides of the face creates distracting shadows. Bangs that come down too low

onto the face will keep light from getting into the subject's eyes—the most important part of the face. Eye makeup should be blended, with no sharp demarcation lines between colors.

Monte Zucker cautions not to use white above or below the eyes—it does not photograph well. And he cautions, "Too much color above or below the eyes may actually draw attention away from the eyes, rather than attracting the viewer to them."

Some photographers want the senior girls to do their own makeup.

Lipstick is always recommended, but eyeliner application should be minimal because it makes the eyes look smaller. Foundation makeup, if it is used, should be blended at the jawline, so that there is no demarcation line between the face and the neck. When the makeup application is complete, finish it off with matte powder, which reduces shininess and specular reflections.

More makeup advice comes from Ralph Romaguera's senior web site: "Makeup for photographs should be only slightly heavier than normal. Too much makeup tends to give you that 'painted look.' Too little might not show off your best features. A loose translucent powder is helpful to eliminate shine, especially for oily skin. Since most portraits concentrate on the eyes, great care should be taken to make them perfect. Avoid using excessively bright colors, and ensure mascara is neat and without clumps."

Ellie Vayo offers this tip for cover-up makeup for both guys and girls: "Here's a quick hint that will gently enhance your portraits: Just before your session, stand two feet in front of your mirror. Dab a small amount of cover-up makeup on any noticeable blemishes. That's it—if they're

gone in the mirror they'll be gone in your photographs!"

Jeff Smith does not recommend an on-site makeup artist. He says, "Many studios offer this and we have tried it before, but I don't suggest it—95 percent of the senior girls have a definite way they wear their hair and makeup. The one comment I hear more than any other about makeovers is that, 'It looks OK, but it doesn't look like me.'"

Other photographers feel just as strongly that makeup is an essential

part of the senior portrait session for girls. They feel that with the expert touches of a professional stylist's corrective measures, such as improving bone structure or the size of a girl's eyes, for example, it becomes an integral part of the service.

Regarding hairstyling, Romaguera instructs, "Hairstyling should be appropriate to the clothing selection. Avoid new hairstyles or having your hair cut or permed the week before your appointment to allow your hair to adjust to the change. If

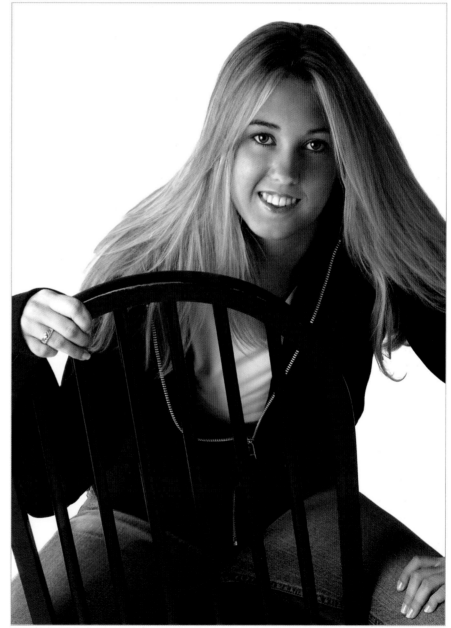

Deborah Lynn Ferro is a Chanel Cosmetics–trained makeup artist and she usually works with her senior girls before each photo session, applying a non-glare foundation, lip gloss, and minimal eye makeup. This senior's hair and makeup are both flawless. The makeup experience is a great confidence builder for seniors—something that certainly shows in Deborah's photo.

you would like to change your hairstyle during your session, this can add a little more variety to your photographs. It should, however, be a simple change that can be done quickly."

The Makeover

The makeover is designed to give senior girls a look they never knew they had. It involves a full makeup and styling treatment and a premium glamour photo session that is designed to create a new, albeit sexy look for the senior. The girls are encouraged to bring formal attire and have their hair done, and the studio will handle the rest. A professional makeup stylist is on hand and should be both expert and stylish. The session will involve on-axis fashion type lighting and will involve full retouching so that the girl will literally look like a movie star when the prints are delivered.

Rick Pahl, an extremely gifted senior photographer, offers a variation of the makeover fashion shoot to his seniors. Pahl refers to all his clients as models and he treats them as such. With senior girls he creates a kind of fashionable "jeans ad"— and even with senior boys, he has been known to encourage them to take their shirts off for what he calls the "beefcake" shot, which he says "constantly amaze the females in our little town."

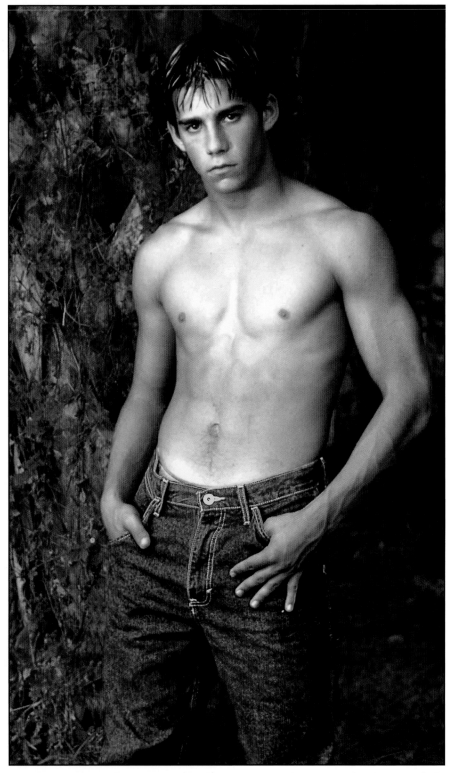

One of Rick Pahl's "beefcake" shots, which he says, "constantly amaze the females in our little town."

Seniors are often photographed in studio using studio lighting, or just as often, on location, also using studio lighting. While traditional portraits are sometimes made, most seniors, because their complexions are often not perfect, are best photographed with diffused light. Diffused or soft light sources minimize facial blemishes and also simplify the retouching process. Soft lighting is also easier to deal with from the photographer's point of view.

Almost all studio lighting these days is electronic flash, as opposed to incandescent light sources, which are hot both to handle and for the subject. Strobe systems use modeling lights

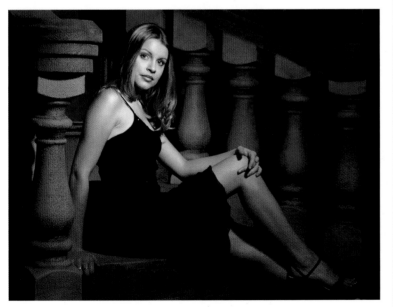

Jeff Smith created this striking portrait by using only a single key light above and to the left of his senior model. He "feathered" the light so that it would fall off in intensity and so that the core of the light was centered on her face. The light itself was used in a parabolic reflector with barn doors and its harsh quality was used to advantage to produce a dramatic quality to the light.

that mimic pretty closely the lighting effect that will be created by the flash tube when it fires. Modeling lights are usually quartz-halogen tubes, which are very bright and small, and the lights themselves are made variable by use of a dimmer control switch for each light. These lights help the photographer determine the exact lighting configuration desired.

The Illusion of Three Dimensions

A photograph is a two-dimensional rendition of a three-dimensional subject. A photograph is an illusion. Lighting is the primary tool by which photographers create the illusion of three dimensions. Put another way, the primary goal of your use of light in portraiture is to show roundness and three-dimensional form in the final image.

The human face consists of a series of planes, none of which are completely flat. The face is sculpted and round. It is the job of a portrait

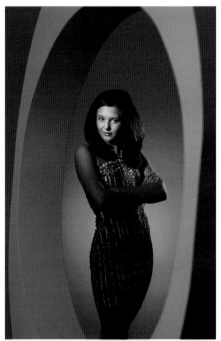

Below—Ralph Romaguera used a softbox very close above and slightly behind his subject to create a delicate lighting pattern. The catchlights in the eyes were refined in Photoshop and the image was also transformed to grayscale. The rose and rose petals were restored to full color, as were the irises of her eyes, which contain subtle rose coloring. **Right—**Larry Peters used a single key light in a reflector with barn doors to light Mallory. He feathered the light so that just the core of the light was used on her face. Notice the directional quality of the light and sharp shadows that it produces. Peters also used a small background light on a stand behind his senior to illuminate the background. A small kicker, placed behind and to the senior's left at around head height, was used as a hair light.

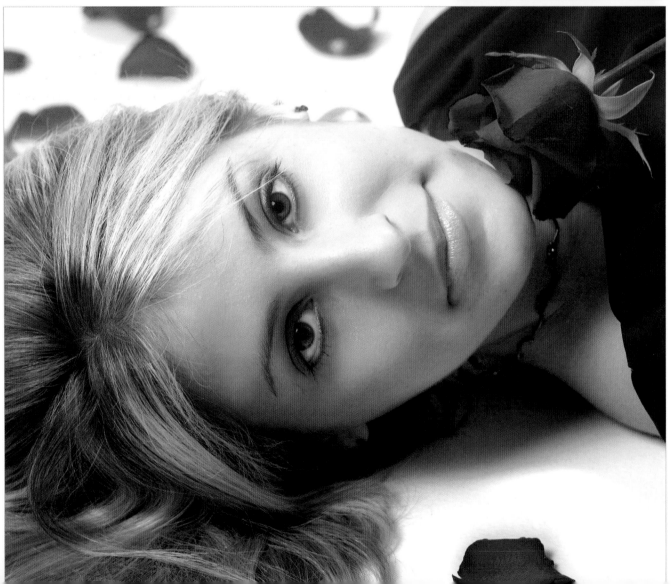

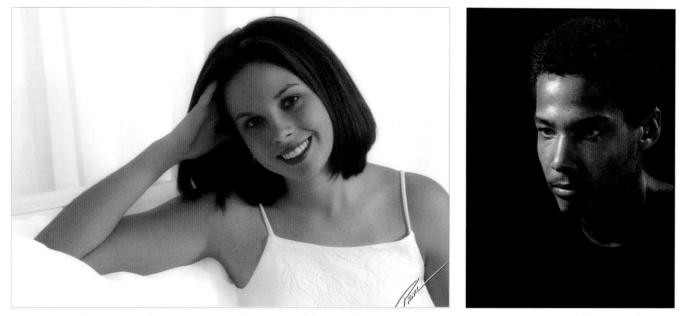

Left—Rick Pahl created an interesting portrait that combines high key clothing and props with a soft light that produces a fairly strong lighting ratio. Ordinarily, in a high key portrait, the fill light would be very close in intensity to the key light, but here, Pahl opted for a relatively weak fill light used just above the camera. The lighting ratio pictured is around 3:1. The main light was a large softbox positioned slightly lower than the head height of the subject. **Right**—This is a beautifully lit portrait by Richard Pahl. The effect he was going for was to produce good highlight brilliance in the skin, which he accomplished by using a strong key light to the subject's right and almost behind him. He used a very weak diffused fill-in source and a weak backlight to light the far ear and subject's neck. Highlight brilliance is when you get detail within a broad highlight and also specular (pure white) highlights within the main highlight.

photographer to show the contours of the face. This is done primarily with highlights and shadows. Highlights are areas that are illuminated by a light source; shadows are areas that are not. The interplay of highlight and shadow creates roundness and shows form.

Key and Fill Lights
The two main lights used in portraiture are called the key light and the fill light. The key and fill lights should be high intensity lights in either reflectors or diffusers. Parabolic reflectors are silver-coated "pans" that attach to the light housing and reflect the maximum amount of light outward in a focused manner. Most photographers don't use parabolic reflectors anymore, opting for diffused key and fill-light sources. If using diffusion—umbrellas or softboxes—the entire light assembly should be supported on sturdy light stands or boom stands. Diffusion light sources use small reflectors within the umbrella or softbox to focus the light onto the outermost translucent surfaces of the diffusion device.

The One-Light Lighting Effect
All lighting setups, whether you use ten lights or two lights, should mimic the one-light lighting pattern created in nature by the sun. This is a lighting basic that is often not followed precisely in the interest of having multiple light sources and lots of lighting intensity. If we lived on a planet with two suns, we would have a different view of portrait lighting, but since we don't, all basic lighting patterns mimic the sun, a single source of light. All other lights are less intense and modify the basic lighting pattern created by the key light.

Differences Between Direct and Diffused Light
Undiffused light that emanates from a light and parabolic reflector is sharp and specular in nature. It produces crisp highlights with a definite line of demarcation at the shadow edge. The highlights that an undiffused light source produces often have miniscule specular highlights within the overall highlight—a phenomenon often referred to as highlight brilliance.

Undiffused light sources take a great deal of practice to use well, which is probably why they are not

used too much anymore. Diffused light sources are much simpler to use. They are a broad, large light source that bathes the subject in light. Softboxes, umbrellas, strip lights, and all of the unique names lighting manufacturers have come up with for diffusion devices do just one thing—misdirect the outgoing beam of light. As the light passes through the diffusion material of these devices it is bent in many different directions at once, causing it to become diffuse.

Not only is diffused light softer, but it is also significantly less intense than raw light. It stands to reason that as raw light rays are bent in an almost infinite number of ways, these light rays scatter and lose intensity.

A large diffused key light often doesn't need a separate fill light, since the highlights tend to wrap around the contours of the face. If any fill source is needed, it is usually in the form of a reflector, used to redirect strong light back into the shadow areas of the face.

Hair and Background Lights

The hair light is above and behind the subject. It used to always be an undiffused light with barn doors to control the width of light emitted. Nowadays, small diffused light sources, such as strip lights, are often used (on boom stands or on ceiling-mounted lighting systems) to light both hair and background. The hair light is used primarily to place highlights in hair, which further increases the illusion of depth and three-dimensionality.

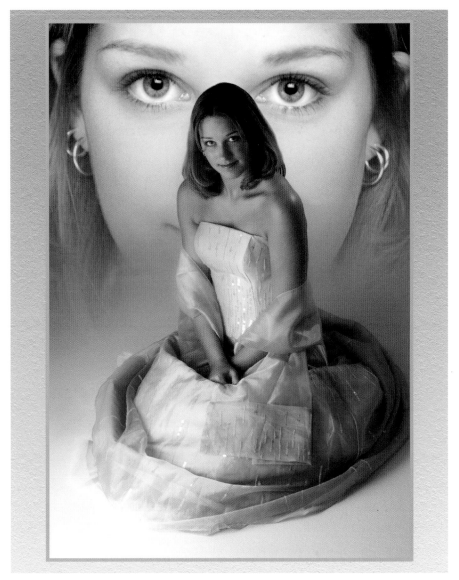

Larry Peters combined two portraits of Sarah for an interesting montage. The background portrait was made with on-axis fashion lighting—very soft light used very close to the girl, directly overhead. The color portrait was made with a soft side light and small back light, which created a nice highlight along the line of her shoulder and also added some highlights to her hair.

The background light is used to illuminate the background so that the subject and background will separate tonally. The background light is sometimes an undiffused light in a reflector with barn doors used on a small stand placed directly behind the subject, out of view of the camera lens. It may also be a diffused light source placed high and out of the way on a boom stand, and will light the background from either side.

Some photographers, like Larry Peters, an award-winning senior photographer from Dublin, Ohio, uses a 4x6-foot permanently mounted softbox in the ceiling that acts as a hairlight and also separates the subject from the background by adding a soft glow around the shoulders. Peters also uses what he calls "separation lights," which are twelve-inch square softboxes with colored gels over the light source (inside the softbox). These are posi-

tioned behind the subject at 45-degree angles and add separation and a rim highlight around the subject. Often these types of lights are referred to as "kickers."

It should be noted that background lights, hair lights, and kickers should not be more intense than the key light. If the large key light puts out an exposure of f/8, the above-mentioned background lights (positioned behind the plane of the subject) should produce an exposure of f/5.6 or f/4. Otherwise, they will overpower the main light and destroy the one-light effect.

Broad and Short Lighting

There are two basic types of portrait lighting. Broad lighting (shown in the bottom right image) means that the key light is illuminating the side of the face turned toward the camera. Broad lighting is used less frequently than short lighting because it flattens and de-emphasizes facial contours. It is often used correctively to widen a thin or long face.

Short lighting (shown in the top right image) means that the key light is illuminating the side of the face turned away from the camera. Short lighting emphasizes facial contours, and can be used as a corrective lighting technique to narrow an overly round or wide face. When used with a weak fill light, short lighting produces a dramatic lighting with bold highlights and deep shadows.

With a diffused key light, the differences between broad and short lighting are not as dramatic as with an undiffused key light.

When used very close to your subject, a softbox will seem to wrap light around the curved planes of the face. Here, Deborah Lynn Ferro used a 4x4-foot softbox very close to her subject with no fill source. The effect is to create a dramatic but soft lighting pattern. Notice the beautiful roundness and contouring. This is a good example of short lighting. Deborah also used a borders effect and Photoshop's Crosshatch filter (found under Filters>Brush Strokes) to give a very painterly look to the photograph.

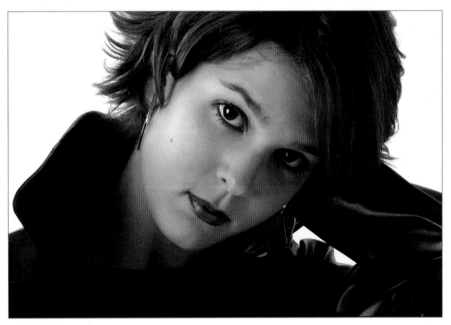

Broad lighting can be very effective when used with a subject who has a thin face or petite features. Deborah Lynn Ferro created this beautiful portrait of Natalie using a large softbox at eye height. The light is feathered to produce beautiful roundness on the highlight side of her face.

Umbrellas and Softboxes

Umbrellas and softboxes are ideal lighting solutions for senior portraits. A single softbox will produce beautiful soft-edged light, which is quite forgiving and produces large elegant highlights, a low lighting ratio (see below), and beautiful wraparound light. Umbrellas, including the shoot-through type, are used similarly.

To get the maximum effect from a softbox or umbrella, the light should be positioned close to the subject. The farther away it is, the less diffused it will be.

Photographic umbrellas are either white or silvered or a combination of both. Softboxes are highly diffused and may even be double-diffused with the addition of a second "scrim" (light diffusing material) over the lighting surface. In addition, some softbox units accept multiple strobe heads for additional lighting power and intensity.

A silver or gold foil-lined umbrella produces a more specular, direct light than a matte white umbrella. When using lights of equal intensity, a silver-lined umbrella can be used as a key light because of its increased reflectance. It will also produce wonderful specular highlights in the overall highlight areas of the face.

Some umbrellas come with intermittent white and silvered panels. These produce good overall soft light but with specular highlights. They are often referred to as zebras.

Umbrellas, regardless of type, need focusing. By adjusting the length of the exposed shaft of an umbrella in a light housing you can optimize light output. When focusing the umbrella, the modeling light should be on so you can see how much light spills past the umbrella surface. The umbrella is focused when the circumference of the light matches the perimeter of the umbrella.

Softboxes do not have to be focused, as the position of the light within the device housing is optimized for best overall effect.

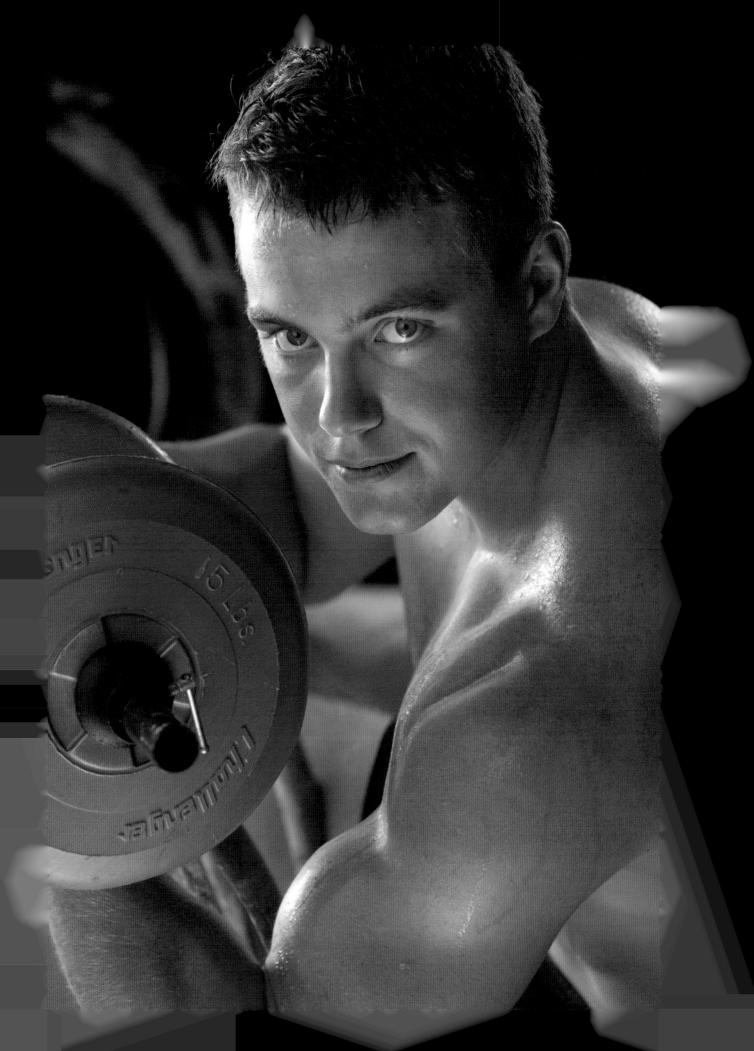

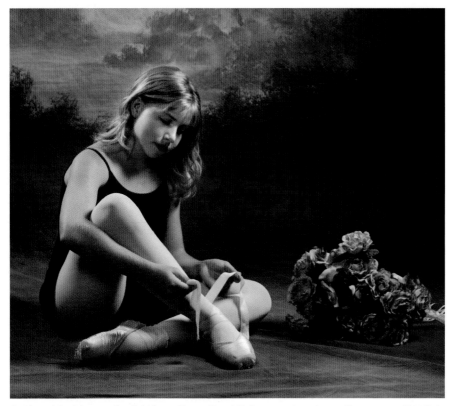

In the original image, the lighting ratio on the girl's face was too strong. You can see that it is still strong in other areas of the image. The photographer, Ira Ellis, liked the pose and went in and selectively dodged areas of her face and neck, reducing the overall lighting ratio on her face and thus "saving" the image.

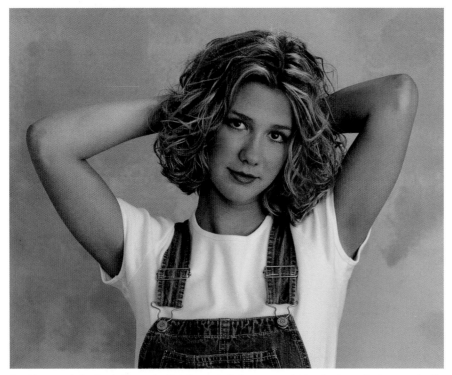

In this portrait by Frank Frost, the lighting ratio is low—around 2:1. Frank used a large umbrella close to his subject and a small, equal-intensity strobe at the camera position. There is good contouring by the light, but little difference between the shadow and highlight sides of the face. Frost also used a diffused hair light just above the subject's head to highlight her hair.

Lighting Ratios

The term describes the difference in intensity between the shadow and highlight sides of the face and is expressed as a ratio—3:1, for example, which means that the highlight side of the face is three times brighter than the shadow side of the face.

Ratios are useful because they determine how much overall contrast there will be in the portrait. They do not determine the scene contrast (the subject's clothing, the background, and the tone of the face determine that), but rather, lighting ratios determine the lighting contrast measured at the subject. Lighting ratios indicate how much shadow detail you will have in the final portrait.

Since the fill light or source controls the degree to which the shadows are illuminated, it is important to keep the lighting ratio fairly constant. A good lighting ratio for color negative film is 3:1 because of the limited tonal range of color printing papers. Black & white films can tolerate a greater ratio—up to 8:1—although at this extreme it takes a near-perfect exposure to hold detail in both highlights and shadows.

Ratios are determined by measuring the intensity of the fill light on both sides of the face with a hand-held incident light meter, and then measuring the intensity of the key-light side of the face only. If the fill light or reflector is next to the camera, it will cast one unit of light on each side (shadow and highlight sides) of the face. The key light, however, only illuminates the high-

light side of the face. If the key is the same intensity as the fill light, then you have a 2:1 lighting ratio.

When using diffused light sources like umbrellas and softboxes and your fill source is a reflector, you cannot meter light ratios in the manner described above. Extinguishing the key light would eliminate the reflected fill light. Instead of using an incident meter, which measures the light falling on the subject, it is best to use a reflected light meter, a spot meter, for example, which reads a very narrow angle of view—1 to 5 degrees. You can thus determine the difference in exposure values between the highlight value and the shadow value reading. Decreasing the ratio may mean moving the reflector closer to the shadow side of the subject's face or redirecting the angle of the key light.

A Wall of Fill Light

One technique that is used widely to produce a beautiful overall fill light is to bounce one or more raw lights into a large reflective surface, like a white wall or large diffusion panel placed behind the camera. In Ira and Sandy Ellis's studio in Westlake, California, they use a huge flat made of plywood painted white and suspended behind the camera position with rope and pulleys. The flat, since it is suspended by adjustable ropes, can be angled downward toward the set. An undiffused strobe (sometimes two strobes) is bounced into the large flat and a wall of beautifully soft fill light envelops the entire set. Because of the nature of light, the fill light falls off in intensity the

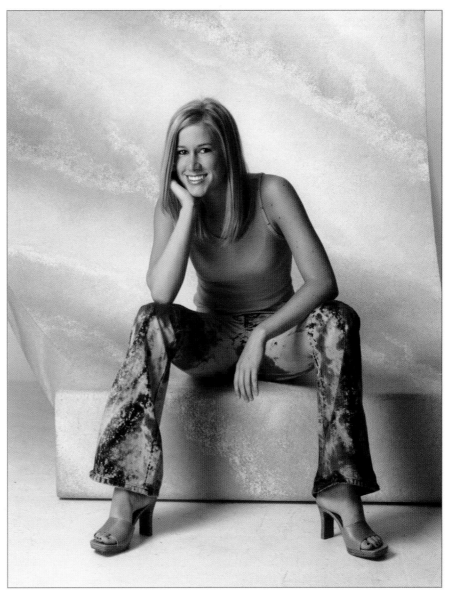

Senior photographer Jeff Smith created a large diffused light source by placing two large softboxes to the left of the lens but on the same axis as the girl's face. The effect is a fashion-light look with open shadows and even lighting throughout. The dual lights helped to create a wall of light that fully and equally illuminated the entire set.

farther it must travel. Therefore, in this example, the light is brightest at the subject position and falls off at the background distance (see the diagram on page 64). However, it is ideal for producing an even light level for the fill light, thus eliminating the need for individual reflectors. In this example, Ira and Sandy Ellis use a diffused key light (in a large softbox or shoot-through umbrella, and smaller diffused hair and background lights. These are miniature softboxes, often called strip lights.

The Ellis studio developed this lighting technique because they photograph a number of small children each year, and they cannot remain in one spot for too long. Thus a broad diffused light source is used to provide overall fill in.

Other well-known portrait photographers like Michael Ayers and

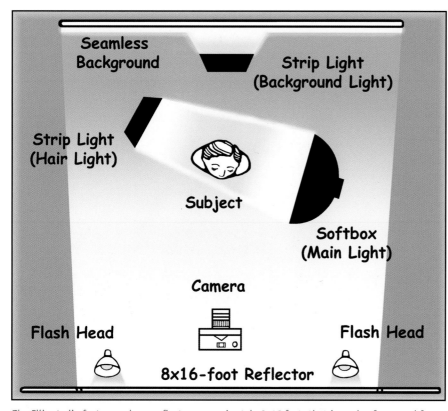

The Ellis studio features a large reflector, approximately 8x16 feet, that is made of an wood frame and lightweight reflective material stapled to it. Rope pulleys mounted overhead and to the back wall support the frame, allowing Ira to lower or angle the flat down toward the set. One or sometimes two barebulb flash heads are bounced into the flat to produce a "wall" of fill light that literally floods the set. The barebulb flash output is usually set to produce about a stop less overall light than the large softbox, which is used as a key light. Strip lights on boomstands are used for hair and background lights. A variation of this is to bounce flash off of a neutral-colored back wall behind the camera. Diagram by Shell Dominica Nigro.

Norman Phillips use the same principle but bounce the light off light- or neutral-colored studio walls directly behind the camera position. Instead of the light having an overhead nature, like it does in the Ellis studio, the fill light level is on the same axis as the subject, much like a fashion light.

Fashion Lighting

Fashion lighting is a variation of conventional portrait lighting. It is extremely soft and frontal in nature—usually the main light is on the lens/subject axis. Fashion lighting does not model the face, make-up primarily does that. It is a stark lighting style that is usually accomplished with a large softbox directly over the camera and a silver reflector just beneath the camera. Both the light and reflector are very close to the subject for the softest effect.

When you examine the catchlights in a fashion portrait you will see two—a larger one over the pupil and a less intense one under the pupil. Or sometimes you will see a circular catchlight produced by a ringlight flash—a macrophotography type of light that mounts around the lens for completely shadowless lighting.

Fashion lighting is a big favorite for girl's senior photography or for a makeover, which involves professional hairstyling and a makeup artist. When it comes to male fashion portraiture, however, the trend is different—you want a bold, dramatic, masculine look. Flat lighting is seldom used with men. Side lighting with bold, hard shadows and very little fill seems very popular.

Feathering the Lights

Lights must be set with sensitivity—even large, forgiving diffused lights like softboxes. If you merely aim the light directly at the teen, you may "overlight" the subject, producing pasty highlights with no detail.

You should adjust the key light carefully, and then evaluate the effects from the camera position. Instead of aiming the light so that the core of light strikes the subject, "feather" it so that you employ the edge of the diffused light to illuminate your subject. The goal is to add brilliance to your highlights. The highlights, when brilliant, have minute "specular (pure white) highlights" within the main overall diffused highlight. This further enhances the illusion of depth and three-dimensionality in a portrait.

Reflectors

Reflectors are any large white, silver, or gold surface that is used to bounce light into the shadow areas of a subject. A wide variety of reflectors is available commercially, including the kind that are collapsible and store in a small pouch. Reflectors can be translucent, silvered,

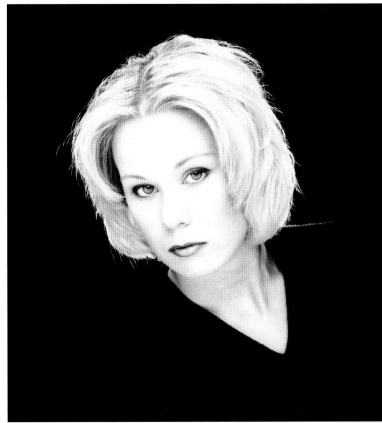

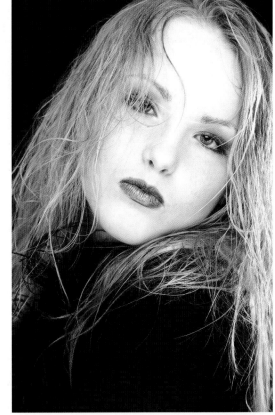

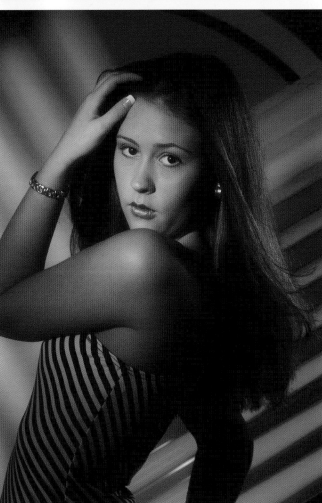

Top Left—Here is another good example of fashion lighting by senior expert Ralph Mendez. An umbrella is used over the lens and very close to the senior. In this image, Ralph underprinted the face to remove most of the detail, a technique that also minimizes retouching. He also used hair lights behind the subject on both sides at 45-degree angles. **Top Right**—True fashion lighting is on-axis with the camera lens. Here, Larry Peters has a large softbox atop the lens and a reflector beneath the lens to produce a column of shadowless light. Since the lighting in these types of shots does not contour the face, it is important that makeup be expertly applied to define the cheekbones and other frontal planes of the face. **Right**—In this dramatic portrait, award-winning photographer Larry Peters used a single key light in a parabolic reflector with barn doors to narrow the beam of light. He feathered the light to get the dynamic core of the light to produce good contouring and highlight detail. In the background, the color stripes are actually a Peters original—one- or one-and-a-half-inch acrylic rods with gel-filtered strobes duct-taped to the rods. The flash units are slaved so they fire at the same time the main lights do. They look like laser beams and, in fact, that's what the kids call them.

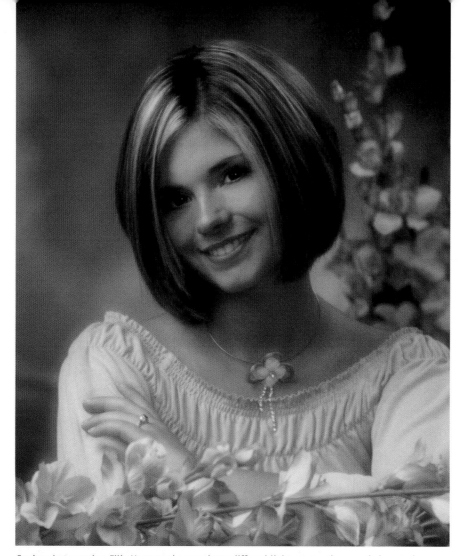

Senior photographer Ellie Vayo used a very large diffused light source above and close to her senior subject to create a "glamour-type" lighting pattern. She then used a small reflector beneath her subject to kick light up into the shadows. The key light is much stronger than the reflector fill. A background light was also used.

black (for subtractive lighting effects), or gold-foil surfaced. The silver and gold foil surfaces provide more light than matte white or translucent surfaces and the gold surfaced reflectors are ideal for shade outdoors, where a warm-tone fill is desirable.

When using a reflector, it should be placed slightly in front of the subject's face, being careful not to have the reflector beside the face, where it may resemble a secondary light source coming from the opposite direction of the main light. This is counterproductive. Properly placed,

the reflector picks up some of the main light and wraps it around onto the shadow side of the subject's face, opening up detail in even the deepest shadows.

The Softer the Better

Photographer Brian King uses very soft light to photograph his seniors. In combination with some minimal retouching in Photoshop, he produces a very distinctive look for his seniors based on soft lighting. It is for very good reason that Brian King is one of the hottest senior photographers in the country.

"I try to keep my lighting simple. I use Photogenic Powerlights. My main light is in an Aurora seven-foot Light Bank and my fill light is shot into a Westcott three-foot-diameter silver umbrella. Sometimes I use a silver reflector for fill instead of the umbrella when I'm photographing real tight head shot images or when I'm using window light. Our window light area consists of three 3x6-foot windows spaced just under two feet apart. I work with my main light in as close as possible. Because of the size of the box and the close location, the catchlight is large and, most of the time, very subtle."

Retouching

"Our clients' images typically get basic retouching to remove blemishes and soften facial lines," says Brian King. "Typically, there is no major wrinkle or crease work done unless requested by the client. I am not very proficient in Photoshop and have only been working with the program since last spring, so my techniques would probably send chills down the spines of those in the know. Basically, I take the images a bit farther than the lab (Buckeye Color in Canton, Ohio) by adding additional work under the eyes and smoothing out facial areas with larger pores with the blur tool. My favorite treatment so far is to clean up the whites of the eyes with either a brush tool or the dodge tool and then deepen the existing eye color. I've been having fun playing with the saturation levels and also the Gaussian blur filter to create a more defined selective focus."

Here are six close-up looks at two types of ultrasoft lighting Brian King uses for seniors. Note that in the eyes of these images you can discern the lighting pattern—the shape of the main light and fill light or reflector. You can also get a good look at the kind of retouching King does to the images around the eyes.

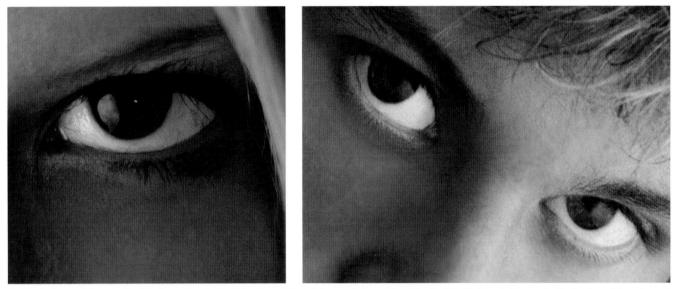

Left—Softbox with umbrella fill. The odd catchlight in the middle of the eye is from the umbrella-fill. **Right**—Softbox only. Notice how Brian cleaned up the whites of the eyes in Photoshop.

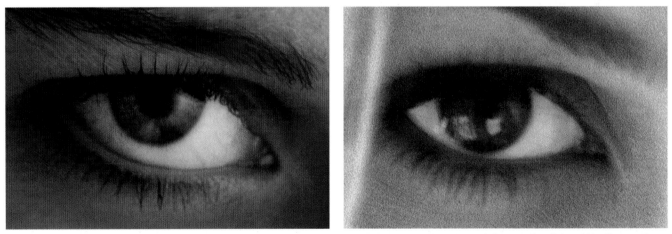

Left—Softbox with reflector. You can also see how Brian intensified the color of the eyes in Photoshop. **Right**—Window light with reflector. If you study the catchlights, you can see the large window at left and the smaller reflector fill at right.

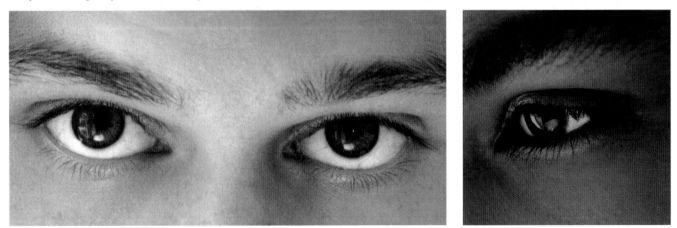

Left—Window light with reflector. The type of retouching done is subtle—softening large pores in the skin and blending blemishes. Little "crease work" is done to his seniors. **Right**—Window light with reflector. You can see that the reflector is a different color than the neutral window light. All images shown here were captured digitally.

NATURAL LIGHTING
FOR SENIORS

*L*earning to master light outdoors and recreate studio lighting patterns in nature expands the photographer's realm of shooting on location. Seniors as well as kids of all ages react well to being photographed outdoors. They are often more at ease in natural surroundings than they are in the formal setting of the studio.

Control of outdoor lighting is really what separates the good photographers from the great ones. Learning to control, predict, and alter daylight to suit the needs of the portrait will help you create elegant natural-light portraits consistently.

Above—A window seat in a home is like a huge softbox. Ellie Vayo uses the ultra-soft light of a north-light window to create a striking senior portrait. Using a single medium-sized reflector from below lessens the lighting ratio and opens up the shadow side of her subject's face. *Facing Page*—One of the softest and most effective types of portrait lighting is window light. Deborah Lynn Ferro created this striking portrait with window light from a bay window and a single reflector.

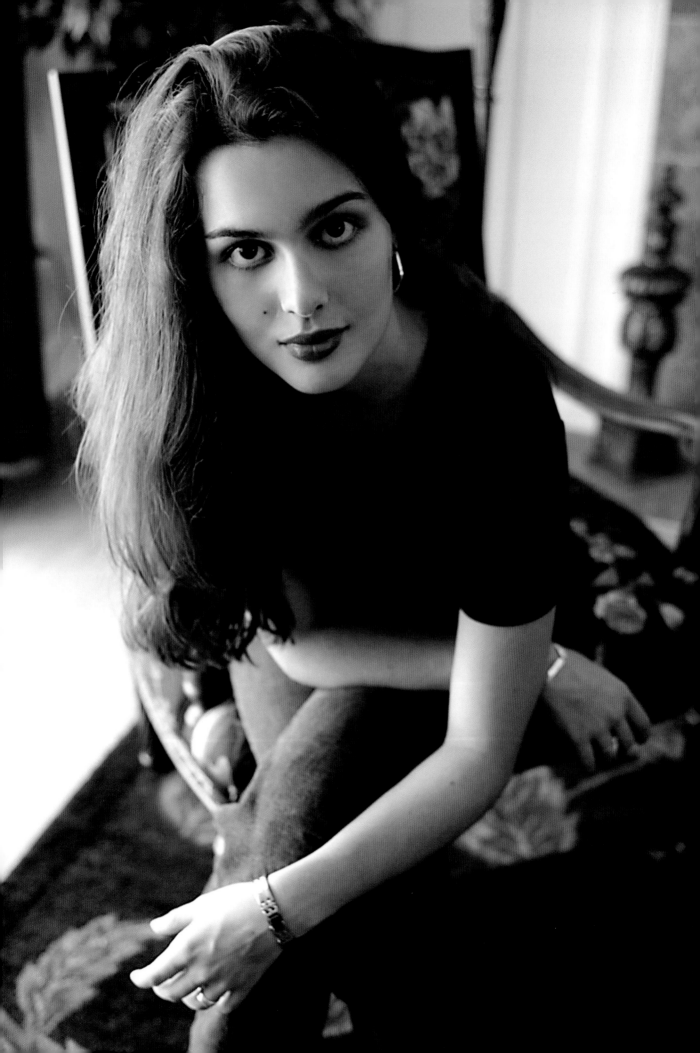

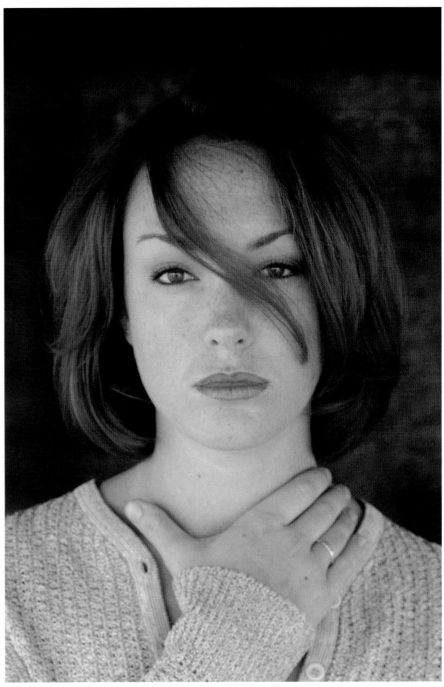

Top—Robert Love created this portrait completely by available light. This image was created just after the sun had gone behind the mountains, creating a large softbox style of light. Notice the beautiful almost high-key ratio of the light and its effective modeling. **Above**—Tammy Loya's studio features a huge north-light window that Tammy uses as a key light. She changes the background and props for different portraits, making it look like she has four or five different camera rooms. This is a window-light portrait of her teenage son. **Right**—Using two large bay windows as frontal light, Gigi Clark created a fashion type of lighting for Heather's portrait. No fill was used, and if you look closely at the catchlights, you can see the photographer's silhouette in the midst of the two long catchlights.

Window Light

One of the most beautiful types of lighting is window lighting. A soft wraparound light that minimizes blemishes, it is also highly directional and yields excellent modeling with low to moderate contrast. Window light is usually fairly bright; it is infinitely variable, changing almost by the minute, allowing a variety of moods depending on how far you position your subject from the light.

The larger the window or series of windows, the more the light envelops the subject, wrapping your subject in soft, delicate light. Window light seems to make eyes sparkle exceptionally bright, perhaps because of the size of the light source relative to the subject.

Since daylight falls off rapidly once it enters a window, great care must be taken in determining exposure. You will need reflectors to kick

light into the shadow side of the face, and you will undoubtedly need an assistant to position the reflector so you can observe the effects at the camera position.

The best quality of window light is the soft light of mid-morning or mid-afternoon. Direct sunlight is difficult to work with because of its intensity and because it often creates shadows of the individual window-panes on the subject.

Diffusing Window Light. If you find a nice location for a portrait but the light coming through the windows is direct sunlight, you can diffuse the light with a translucent panel or scrim positioned in the window frame. A device made specifically for diffusing window light is a translucent lighting panel, such as the 6x8-foot one made by Westcott. It is collapsible but rigid when extended and can be leaned into a windowsill to create beautiful north light that, because of the direct sunlight, appears golden in color.

Sunlight diffused in this manner has all of the warm feeling of sunlight but without the harsh shadows. Since the light is so scattered, you may not need a fill source, unless working with several subjects. In that case, use reflectors to kick light back into the face of the person farthest from the window.

Photographing in Shade
By far the best place to make outdoor portraits is in shade, away from direct sunlight. However, shade does not always provide soft light. Particularly on overcast days, shade can be harsh, producing bright

This is one of the most beautiful and well-coordinated senior portraits you'll see. The photographer chose an overhead shade locale because of its beautiful background. He then employed his homemade reflector, made from building insulation and Mylar material. Later, he softened the file using Gaussian blur to about 12 pixels, faded 25%. Notice the incredible color coordination—the lavender lipstick and eye shadow coordinate well with the colors in the background. Photograph by Fuzzy Duenkel. The hair covering the eyes is a Duenkel trademark.

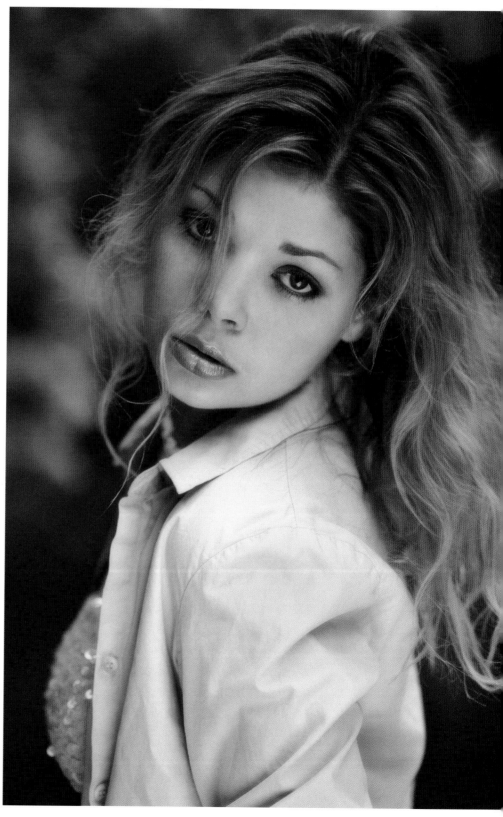

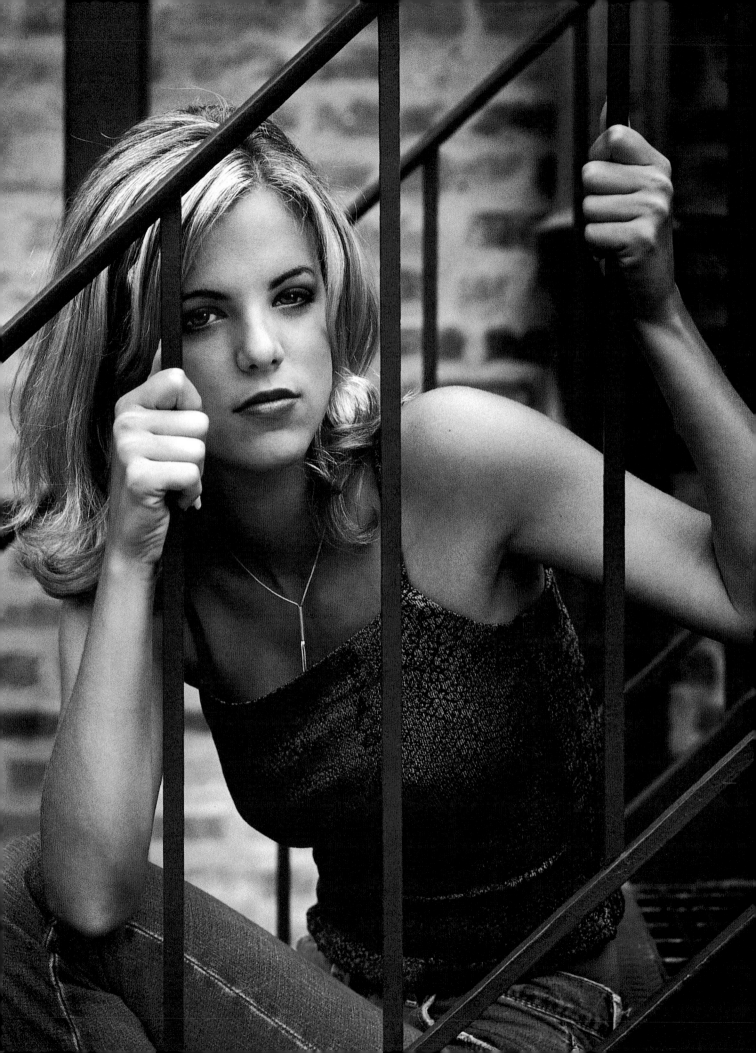

Facing Page—Photographing in open shade can be a nightmare. When you are near large "blockers," in this case, buildings that redirect the overhead shade into side lighting, you have a beautiful portrait light with direction and modeling capability. Norman Phillips created this striking senior portrait of a girl on a fire escape. Above Left—Ellie Vayo's studio property includes hundreds of portrait settings for seniors. Here the brick arch overhead blocks the open shade, allowing the light to become directional from the side. The side lighting produces a gentle rim-light effect; no fill source was needed. Photograph by Ellie Vayo. Above Right—This looks like found light, doesn't it? It's not. Robert Love found a nice location with natural late-afternoon backlighting and augmented it with frontal fill-flash. Love positioned the softbox flash to the subject's right at about a 45-degree angle. The softbox is also elevated to produce good contouring. The flash is set to the same output exposure as the daylight exposure.

highlights and deep shadows, especially around noon. The best shade for portraiture is found in or near a clearing in the woods, where tall trees block overhead light. In a more urban setting, a balcony or porch can also block overhead light. In either case, you will immediately notice that the light is less harsh and has good direction coming from the sides. You can make your own overhang by holding a gobo (a black reflector) over the subject's head. This will block the overhead light, allowing side light to illuminate your subject.

Photographing in Open Shade

Open shade is the light one gets from diffused skylight in an open area. It has an overhead nature and can cause "raccoon eyes"—deep shadows in the eye sockets, and shadows under the nose and lower lip. The effects of open shade are the worst at midday on cloudy days, since the sun is directly overhead.

If forced to shoot in open shade (and this is not always a bad thing—the location and background might be perfect) you must fill in the diffused daylight with a frontal flash or reflector. Using a large silver reflec-

tor close to the subject and slightly below head height, wiggle it back and forth and watch the shadows open up as light strikes these areas. If using flash, the output should be at least one stop less than the ambient light exposure reading, in order to fill and not overpower the daylight. You'll read more about this technique on page 79.

Light Modifiers

Reflectors for Fill. You are at the mercy of nature when you are looking for a lighting location. It is a good idea to carry along several

Left—Don Emmerich created this beautiful portrait of Rose at Red Rocks using the natural overhead diffused daylight and several reflectors, positioned beneath and to the subject's right. Because of the overhead nature of the light, the reflectors were used to redirect the light onto the subject plane and increase the intensity of light on the subject. Right—Another Don Emmerich portrait of Rose uses the naturally reflected fill light of these pillars. The photographer positioned his subject so that the diffused daylight coming in from her left acted like a key light. Don attained a good lighting ratio by placing her behind the massive pillar in the foreground. If he had placed her parallel to the pillar, it would have provided a strong fill, eliminating the lighting ratio. The curves at the base of the pillar at left also serve to lead the viewer's eye toward the subject.

portable reflectors. The size of the reflectors should be fairly large—the larger it is the more effective it will be. Portable light discs, which are reflectors made of fabric mounted on a flexible, collapsible circular frame, come in a variety of diameters and surfaces—white, silver, or gold foil (for a warming fill light), translucent (so that the reflector can be used as a scrim), and black (for subtractive effects).

When the shadows produced by diffused light are harsh and deep, or even when you just want to add a little sparkle to the eyes of your subjects, use a large reflector or even several reflectors. You will need an assistant so that you can observe the effect at the camera position. Be sure to position the reflectors outside the frame. With foil-type reflectors used close to the subject, you can even sometimes overpower the

ambient light, creating a pleasing and flattering lighting pattern.

One effect of using reflectors is that they sometimes make the subject squint. If this happens, change the angle of the reflector.

Gobos. Gobos, or black flags, as they are sometimes called, are opaque black panels that are used as light blockers. In the studio they are used to shield a part of the subject from light.

Outdoors, gobos are often used to block overhead light when no natural obstruction exists. This reduces the overhead nature of the lighting, minimizing the darkness under the eyes. This, in effect, lowers the angle of the main light source so that it works as more of a sidelight. Gobos are often used to create a shadow when the source of the main light is too large, with no natural obstruction to one side or the other of the subject.

Scrims. Scrims are a means of diffusing light. In the movie business, huge scrims are suspended like sails on adjustable flats or frames and positioned between the sun (or a bank of lights) and the actors, diffusing the light over the entire set. A scrim works the same way a diffuser in a softbox works, misdirecting (softening) the light rays that are directed through it.

Monte Zucker has perfected a system of using large scrims—3x6 feet and larger. With the sun as a backlight, he has several assistants hold the translucent light panel above the subject so that the backlighting is instantly diffused. He will use a reflector in front of and close

Below—Richard Pahl harnessed a beautiful side light and enhanced it by the tilt of the senior's head. Although Rick softened a great deal of area in Photoshop using blur techniques, he left his own reflection in Mary's sunglasses—a signature move, perhaps. As you can see by examining the reflection in the sunglass lens, the softness of the light is due to direct sun bouncing off a building to the subject's left. **Right—**Monte Zucker is an expert at using scrims. Here Monte's assistants held a very large scrim between Nikki and the afternoon sunlight. The background is a large stone column, which was softened in Photoshop. The scrim, held fairly close to the subject, produces a soft but directional key light. A reflector was used beneath Monte's lens in order to get some fill light on the shadow side of Nikki's face to create a pleasing light ratio.

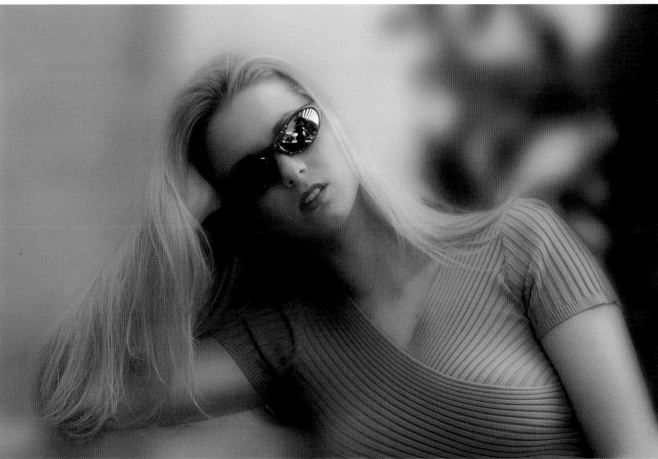

Fuzzy Duenkel created this extraordinary portrait by harnessing the power of shade. The background is a mix of sunlight and shade, and if you look closely at the catchlights in the girl's eyes, you can see a brilliant silver reflector being aimed back at her from beneath and slightly to her right from a close distance. It's hard to believe you can manufacture this kind of light in the woods, but here it is! Fuzzy blended and refined the highlights and shadows in Photoshop.

to the subject to bounce the diffused backlight onto the senior. The effect is very much like an oversized softbox used close to the subject for heavily diffused, almost shadowless light.

Scrims, as mentioned above, can also be used in window frames for softening sunlight that enters the windows. The scrim can be tucked inside the window frame and is invisible from the camera position.

Well known senior photographer Larry Peters uses large scrims to shoot in direct sunlight simply by positioning the scrim between the sun and the subject. The scrim, held by one or more assistants, softens the harshness of direct sunlight while not significantly reducing its brightness. The diffused sunlight on the subject is very soft and there is not much difference between shadow and highlight intensity. The background is not usually more than one f-stop brighter than the exposure on the subject.

Flash Techniques
Flash Fill. More reliable than reflectors for fill-in is electronic flash. For outdoor photography, a great many portrait photographers use barebulb

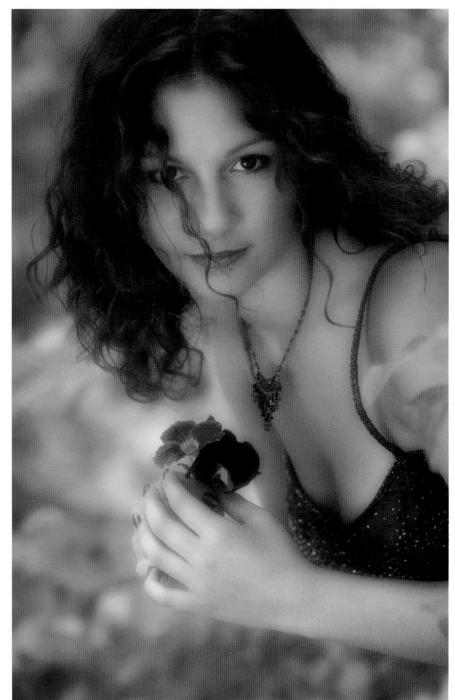

flash, a portable flash unit with a vertically positioned flash tube that fires the flash a full 360 degrees. You can use your widest wide-angle lenses and you won't get flash falloff with barebulb flash, since there is no flash reflector limiting the angle of its beam of light. However, barebulb flash produces a sharp, sparkly light, which is too harsh for almost every type of photography except out-

doors. The trick is not to overpower the daylight. This is the best source of even fill-in illumination.

Other photographers like softened fill-flash. Robert Love, an award-winning photographer from Lake Tahoe, Nevada, for example, sometimes uses a Lumedyne strobe inside of a twenty-four-inch softbox. The strobe is triggered cordlessly with a radio remote. He uses his

flash at a 45-degree angle to his subject for a modeled fill in, not unlike the effect you'd get in-studio.

Another popular flash-fill system involves using on-camera TTL flash. Many on-camera TTL flash systems use a mode for TTL fill-in flash that will balance the flash output to the ambient-light exposure for balanced fill-flash. These systems are variable,

The ability to see good light is a gift. In this beautiful environmental senior portrait by Ralph Romaguera, the main light, directional shade from a building behind the subject, elegantly lit her hair. Minimal fill from below the camera position was required.

allowing you to dial in full- or fractional-stop output adjustments for the desired ratio of ambient-to-fill illumination. They are great systems and, more importantly, they are reliable and predictable. Some of these systems also allow you to remove the flash from the camera with a TTL remote cord.

Determining Exposure with Flash-Fill. First, meter the scene. It is best to use a handheld incident flashmeter, with the meter's hemisphere pointed at the camera from the subject position and the meter in "ambient" mode. In this hypotheti-

cal example, let's say the metered exposure for the daylight is $1/15$ at f/8. Now, with the meter in "flash only" mode, meter just the flash. Your goal is for the flash output to be one stop less than the ambient exposure. Adjust the flash output or flash distance until your flash reading is f/5.6. Set the camera and lens to $1/15$ at f/8.

If the light is dropping or the sky is brilliant in the scene and you want to shoot for optimal color saturation in the background, overpower the daylight exposure with flash. In the same hypothetical situation where

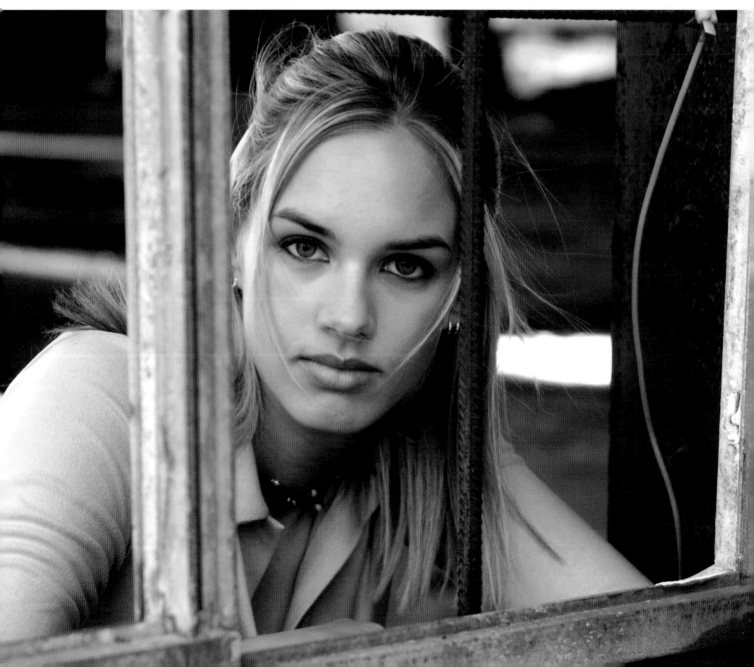

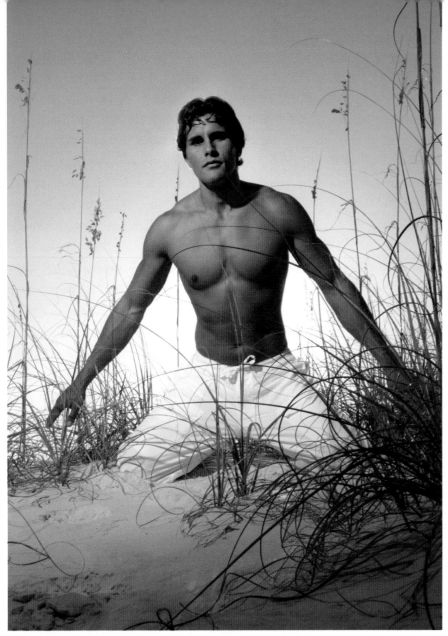

Monte Zucker created this dynamic portrait by positioning this young man on a sand dune with the sun directly behind him. Monte used a barebulb flash positioned above and to the right of his subject to produce a skimming light that would reveal the young man's physique. Instead of filling the shadows, the barebulb flash became the key light, and he underexposed the background by almost two full stops to enhance the colors of the sky.

shutter" it refers to using a shutter speed slower than the X-sync speed in order to expose the background properly. Understanding this concept is the essence of good flash-fill.

Flash Sync Speeds. With the focal plane shutters found in 35mm SLRs, you have an X-sync shutter speed setting. You cannot use flash with a shutter speed faster than the X-sync speed. Otherwise, your negatives will be only partially exposed by the flash. You can, however, use any shutter speed slower than the X-sync speed safely with flash. Your strobe will fire in synchronization with the shutter and the longer shutter speed will build up the ambient-light (background) exposure.

With in-lens blade-type shutters, flash sync occurs at any shutter speed because there is no focal plane shutter curtain to cross the film plane.

Flash-Key on Overcast Days. When the flash exposure and the daylight exposure are identical, the effect is like creating your own sunlight. This technique works particularly well on overcast days when using barebulb flash, which is a point-light source like the sun. Position the flash to the right or left of the subject and elevate it for better modeling. If you want to accentuate the lighting pattern and darken the background and shadows, increase flash output to one-half to one stop greater than the daylight exposure and expose for the flash exposure. Do not underexpose your background by more than a stop or two, however, or you will produce an unnatural nighttime effect.

the daylight exposure was $\frac{1}{15}$ at f/8, now adjust your flash output or flash distance so your flash meter reading is f/11, a stop more powerful than the daylight. Set your camera to $\frac{1}{15}$ at f/11. The flash is now the key light and the soft twilight is the fill light. The only problem with this is that you will get a separate set of shadows from the flash. This can be acceptable, however, since there

aren't really any shadows from the twilight. But it is one of the side effects.

It is also important to remember that you are balancing two light sources in one scene. The ambient light exposure will dictate the exposure on the background and the subject. The flash exposure only affects the subject. When you hear of photographers "dragging the

Many times this effect will allow you to shoot out in open shade without fear of hollow eye sockets. The overhead nature of the diffused daylight will be overridden by the directional flash, which creates its own lighting pattern.

To warm up the facial lighting, but not the rest of the scene, place a warming gel over the barebulb flash's clear reflector (actually it's not a reflector, it's a clear shield used to protect the flash tube and absorb UV—ultraviolet light). Using a gel produces a beautiful effect.

Flash-Fill with Direct Sunlight. If you are forced to shoot in direct sunlight (the background or location may be irresistible), position your subject with the sun behind your subject and use flash to create a frontal lighting pattern. The flash should be set to produce the same exposure as the daylight. The daylight will act like a background light and the flash, set to the same exposure, will act like a key light. Use the flash in a reflector or diffuser of some type to focus the light. If your exposure is $^1/_{500}$ at f/8, for example, your flash output would be set to produce an f/8 on the subject. Position the flash to either side of the subject and elevate it to produce good facial modeling. An assistant or light stand will be called for in this lighting setup.

Even if your strobe has a modeling light, its effect will be negated by the sunlight. It's a good idea to check the lighting with a Polaroid (or on the LCD if shooting digitally). This setup, in the least desirable portrait lighting—direct sunlight—

can still produce some beautiful results. You may, however, want to warm the flash output by placing a warming gel over the flash reflector.

Working at Midday

For award-winning senior photographer Jeff Smith, working at midday has become an economic necessity. The best outdoor locations are thirty to forty minutes from his studio. In order to make it profitable to drive that far for a senior session, he schedules multiple sessions at the same location. The effect of this is that he cannot work exclusively in the early morning or late afternoon when the light is best.

To ensure flattering results in this challenging light, Smith works exclusively in shade for his midday sessions. He tries to find locations where the background has sunlight on dark foliage and where the difference between the background exposure and the subject exposure is not too great. At his subject position he first looks for lighting direction. He always tries to find an area where there is something that is blocking the light from the open sky overhead—a tree branch, roof of a porch, or a black reflector, which he brings along for such situations. If there is no lighting ratio on the face, he creates one using a black gobo on

In a portrait such as this, it is more important to create a dynamic composition than to control the lighting. Ralph Romaguera created this dynamic senior portrait of an aspiring ballerina in overcast midday light. Notice how the most important parts of the photo are white.

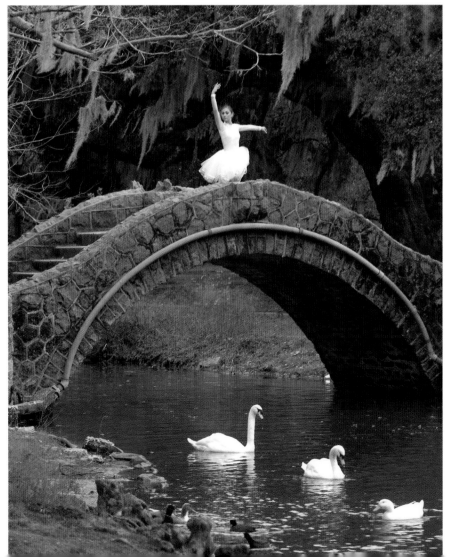

Above—In these two images, both made with telephotos, Fuzzy Duenkel took advantage of the lower contrast of telephoto lenses used at wide apertures. In both instances, he "helped" the backgrounds soften up a little in Photoshop, but in the image of the girl (left), you can see the out of focus highlights perfectly mimic the shape of the blades of the wide-open lens aperture. In the same image, you can see the fill-in effects of the bright foreground, reflected in her sunglasses. In the image of the scuba diver (right), Fuzzy wanted only the senior sharp and blurred the shoreline to focus attention on the boy. **Facing Page**—Jeff Smith, by necessity, is a master at working at midday. He finds the right lighting direction and then either creates or finds or sets up an overhead light-blocking device—like a tree branch or a gobo. He then uses a silvered or white reflector to fill in the frontal planes of the face, depending on which intensity he needs, given the lighting situation.

the shadow side of the face for a subtractive lighting effect.

Since Smith always works in shade, he uses a 400-speed color negative film so that he can work at least at a $\frac{1}{60}$ at f/5.6 exposure. To reduce vibration, he uses the mirror lockup feature on his Mamiya RZ 67 and a heavy-duty tripod.

Once Jeff Smith has the basic lighting and shadowing the way he wants it, he adds a reflector underneath the subject. He uses seventy-two-inch Photoflex gold and white reflectors. He takes the handle of the reflector and loops it over one of the knobs on his tripod and lets the bottom rest on the ground. This is the perfect angle for bouncing daylight up and into the face of his subject. In bright situations, he uses the white reflector, so as not to overpower the natural light. In very soft light he uses the gold reflector. The reflector bounces light from underneath the subject, bringing out

more eye color as well as smoothing the complexion, which is a must for seniors. Smith often diffuses his images on camera to further smooth complexions and to soften and minimize any distracting background effects, like hot spots.

Using Long Lenses to Cut Image Contrast

Lenses longer than 200mm in the 35mm format reduce overall image contrast. Even exotic, very fast (f/2.8 to f/3.5) 200–400mm lenses that use rare earth lens elements and internal focusing and cost what a mid-size sedan used to cost will still reduce image contrast. The longer the lens, the less image contrast it will produce. Part of this is due to internal flare within the lens, and it is sometimes due to the relative imperfection of the lens formula. Although this condition is far better than it used to be, with the introduction of multicoating and other

optical advancements, such as floating lens elements, it is still a somewhat lamentable fact of optical life.

Portrait photographers, however, will often use this characteristic of long lenses to their advantage. Lower image contrast is a desirable characteristic when photographing portraits, especially in shade. When the background is brighter than the subject, the effect is even more attractive when the exposure is biased for the shadows and the hotter background is overexposed.

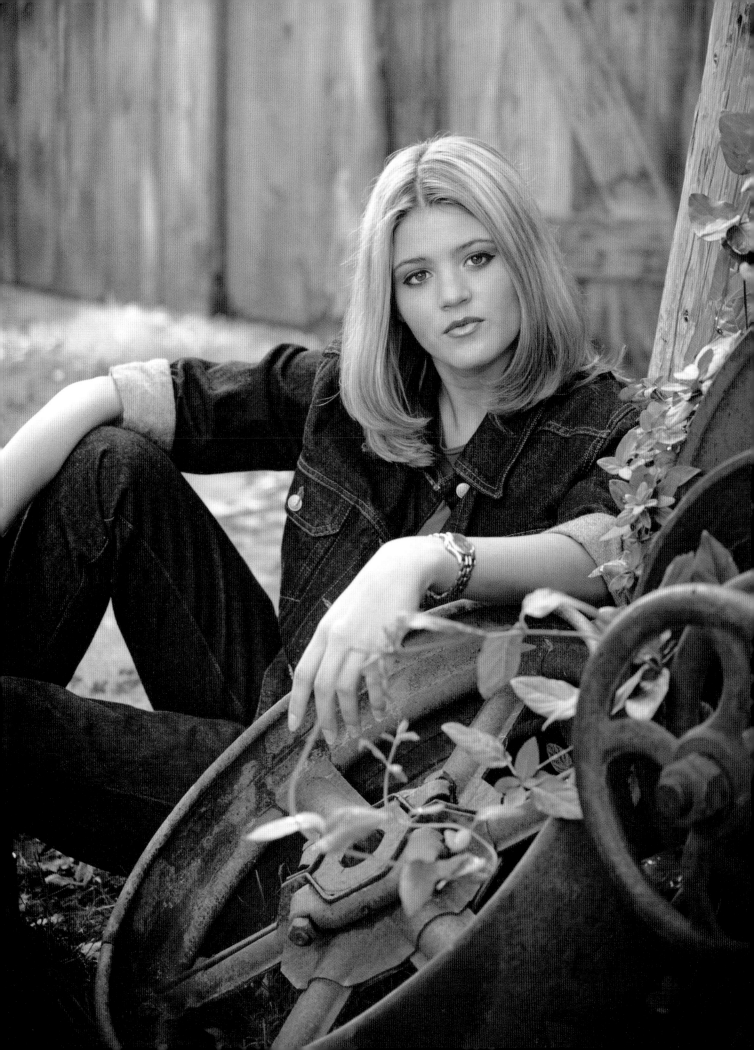

SENIOR MARKETING TECHNIQUES

Creative, wide-open marketing campaigns are now being employed to lure the senior dollars away from the contract studios. By perseverance and a strict "quality photography only" policy, many studios have been able to not only exploit the senior market, but carve out good-size niches for themselves.

Be Consistent in Your Marketing

Scott Cubberly, the president and principal owner of Cubberly Studios in Ohio, says that studios small or large need to make the most of their marketing efforts. "Whether you're doing a single mailer or a comprehensive campaign, be sure your people, your product, and your studio as a whole support your overall mar-

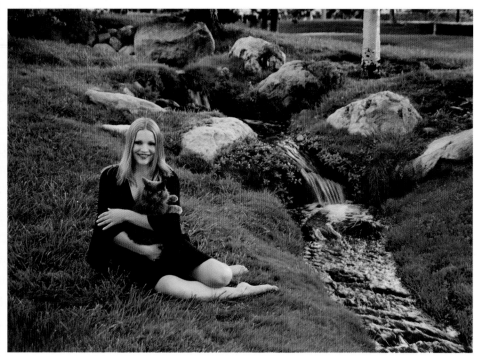

It's always amazing how kids react to their favorite things—in this case, this girl's lovely cat. The senior is completely relaxed and her kitty helps her generate this beautiful smile. The image was created with available light with a Canon EOS A2, and EOS 28–135mm lens, using a Tiffen Warm Soft #4 filter on the lens. The image was created just after the sun had gone behind the mountains, creating a large softbox of light. Photograph by Robert Love.

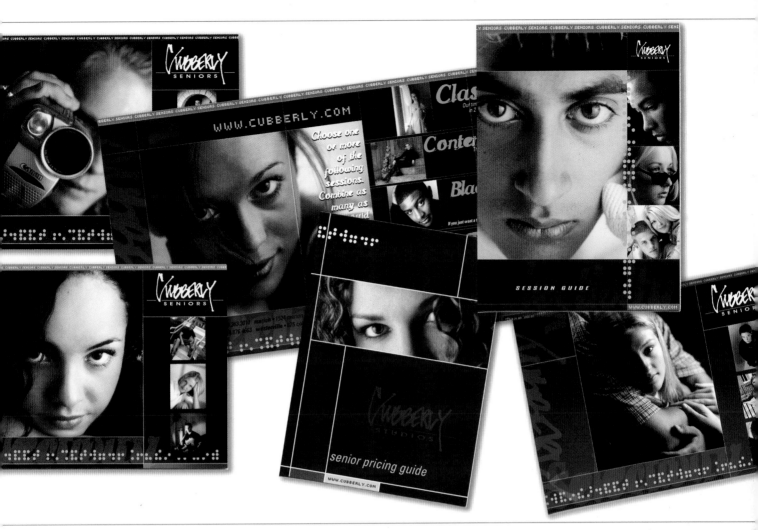

Cubberly Studio's direct mail pieces, whether they are postcards or brochures, always feature bold graphics and big up-close photos of good-looking seniors. Brian King photographs lots of tight face shots and conveys lots of mood and quality with his portraits, so they lend themselves to a hard-hitting direct-mail campaign. The current campaign stems from the web site and video (www.cubberly.com). Every piece is brand identified with the next and carries the same cool graphics and logo designs. You cannot help but admire this campaign, a multiple award winner. The web site for seniors features a Flash- and Shockwave-animated presentation that is incredible.

keting message. In all of Cubberly's marketing materials, including the ten-minute, very hip promotional senior video (described later in this chapter), the graphics, type of imagery, and message are all very similar, so the customer sees a consistency in all the materials they receive from the studio. Like multiple advertising "hits," recurring messages and consistency build identity and product awareness.

Bulk Mailing

When sending out direct-mail pieces, you can save yourself a ton of money by preparing the pieces early and then sending them out third-class bulk mail. Often what happens is that the direct-mail pieces don't get prepared until the last minute, forcing the studio to send them out first-class mail. During your slow time is a good time to prepare lay-outs and develop a schedule for your direct-marketing campaign.

Constantly Evaluate
Your Marketing Program

Award-winning senior photographer Ellie Vayo is constantly evaluating her marketing program for its effectiveness and overall value. She advises, "Rebates, discounts, the barter system with other area vendors—do whatever you can to get your name out there in the most cost-effective way."

Copyright Notice

With the advent of $100 scanners that are incredibly good, many parents, even law-abiding, honest ones, will simply order your minimum

Above—In this perfect senior portrait by Robert Love, the photographer captured the love this senior has for her ballet as well as the beautiful surroundings of her home, the Lake Tahoe area of Nevada. The image is made entirely with natural light and very fast film at twilight—as the sun is going down. Notice the broad soft highlights on her face from the Western sky. **Facing Page**—Fuzzy Duenkel's senior portraits are the equivalent of fine art. Not only are these images exemplary, storytelling portraits taken in the senior's surroundings, but they are simply beautiful pictures. A Wisconsin resident, Fuzzy often makes these exceptional portraits in a barn, an integral part of Midwestern living.

package and scan the prints—and you will never see another dime from them. It is important to prominently note in all your literature and on your web site the basics of the Federal Copyright Law. Here's what Ralph Romaguera's web site (www.romaguera.com) says about copyright:

Under no circumstances may any of the images be copied or reproduced, as Ralph Romaguera Photography retains the exclusive privileges under the Federal Copyright Law. We reserve the photography rights to all images for display or advertising purposes.

The copyright notice is usually printed on other collateral materials as well as on the web site so customers, "can't miss it."

Digital Graduation Announcements
Graduation announcements have always been somewhat impersonal. The announcement itself is usually generic. Traditionally a senior would include a name card or photo to let people know from whom the announcement was coming. Using a page-layout program like Photoshop or QuarkXPress®, you can now create custom graduation announcements for seniors. Each one can be completely different and you can even involve the senior in the design process. Their senior portrait can be the cornerstone of the announcement with custom typefaces and graphics announcing the big day. Custom graduation announcements allow you to include all pertinent

information—including open-house information. The announcements are inkjet-printed on photo-quality paper, and you can also include envelopes so there is nothing left for the senior to do but address the envelopes and mail them!

Direct-Mail Campaigns

The senior market represents one of the savviest groups of consumers anywhere. Yes, they are impressionable, but they are also sophisticated and won't be duped by superficial and insincere marketing efforts. The key, suggests Brian King of Cubberly Studios, is to make sure the students remember you by the impression you make. Your approach must be hip and credible.

Direct-Mail Frequency and Guidelines. In the senior market, direct mail is the most effective form of advertising and it is the cheapest, as well. Do not be discouraged by a low return rate on your direct-mail efforts. Experts say that from 1–2 percent return is good.

Sending out one flyer, postcard, or brochure will probably not have much of an effect on your senior sales. Therefore, you need to repeat your promotions fairly often—as many as eight to ten times a year, some photographers say. Always offer some type of motivation for responding to the promotion—a discount or a free 8x10-inch print, for example—and be sure to include an expiration date on the promotion. Vary the mailings so that you do not send the same size, color, or shape promotional piece; this keeps your campaign fresh. Remember

that teens who have applied to college are usually the first ones to the mailbox each day as they eagerly await news of their futures.

Dollar-a-Day Sessions

For those studios wanting to book early senior sessions, create a Dollar-a-Day session, where session fees are set by the day the senior calls for an appointment. For example, if the senior calls on the first day of the promotion, they pay a one-dollar session fee. If they call on the fifteenth day, they pay fifteen dollars. Urgency creates action and earlier bookings. This tip comes from Buckeye Color Labs in Canton, Ohio.

The "Dream Team"

One of Rick Pahl's favorite promotions is the Dream Team, which is a collection of senior images that hang in his town's (Okeechobee, Florida)

major art gallery. The kids love being featured there, and it is a great business promotion for Pahl because it brings parents with teens into the gallery and exposes families without teens to Pahl's photography—a win-win promotion.

Ellie Vayo's CD Business Card/Portfolio Presentation

"Seniors get bored." That's what award-winning senior photographer Ellie Vayo remembers every time she markets to seniors. "These kids are so visual, so computer-savvy, studios must search for fresh ideas to capture this market."

Ellie has developed an innovative business-card sized CD portfolio that has not only gained seniors' attention, but has won her studio a PPA AN-NE award. She created this marketing idea in-house. "We simply created the files, burned our

Ellie Vayo's CD business card and portfolio is a great idea made possible by an employee's know-how. The little CDs have been one of her studio's most successful promotions, and she offers students a discount for bringing them back at their appointment, so she can recycle them.

CDs, slipped them into sleeves and passed them out like business cards," she says.

Vayo produces about 100 cards at a time at a cost of about a dollar each—and the seniors love them. For further incentive, she offers a ten-dollar discount on the student's session if they bring in the CD at the time of their session—she then recycles them for future seniors.

The "Friends' Promo

Photographer Larry Peters offers seniors the opportunity to bring in friends (up to ten) for a group sitting that he offers for half the price of a regular photo session. The print price list is exactly the same as usual, with one exception: Peters offers a 20x30-inch poster for a reduced price, and it brings in a lot of orders. The beauty of this promotion is that it brings back those seniors he has already photographed, plus some he hasn't. Peters always tries to do something unique with the group and works off of the principle that your high school friends are special and these group sessions can keep those memories alive. Peters also feels that you are making customers for life with such promotions.

How Much Should You Spend?

Experts say that you need to allocate from 5 to 10 percent of your gross income to advertising and marketing. Other studio owners think this is conservative and spend on the order of 15 to 20 percent on advertising and marketing efforts, including direct-mail marketing.

List Brokers

Mailing lists are usually available from local list brokers. This is not usually the best way to get accurate names and addresses, since such lists are often taken from DMV records or from SAT or ACT test rolls. The problem with such lists is that many juniors do not yet have driver's licenses and will not take college boards until the end of their junior year. Still, the list broker might be

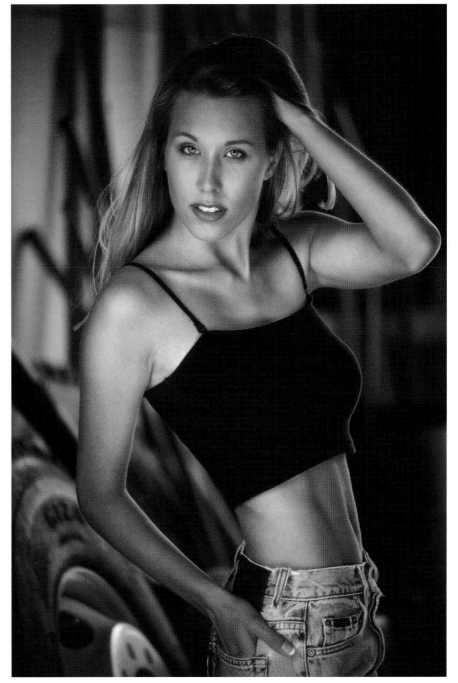

Here's another barn shot by Fuzzy Duenkel, complete with a truck tire in the background. In this portrait, however, Fuzzy created a symphony of backlight that skims across the senior's well-defined abdominal muscles. Fuzzy used two silvered reflectors—one beneath the camera and one to the right of the senior—to create the beautiful frontal light which elegantly contours her skin. This is not the kind of portrait that could even be imagined by the senior contract photographer of just a few years ago.

the only way to get started, and you can refine the list after you encounter a number of qualified leads.

One such list company that many photographers use is the American Student List Company (www.studentlist.com), which offers qualified lists from all over the country sorted by state and county. It's not cheap, but as a one-time cost, it may be a way to get you going in the senior business.

Market in Threes

Ellie Vayo believes that running a single promotion at a time will not ensure success. She always has three marketing campaigns going on simultaneously. "The best marketing program is multifaceted," she says. For example, Ellie has a CD/business card portfolio (see page 86) as an ongoing campaign. She also has radio spots running, and her work is showcased in area malls. People tell her, "I see you everywhere," which of course makes the Ohio senior photographer smile.

Notice of Secondary Usage

Most photographers will include, as part of their bill of sale or contract, a clause that states the photographer reserves the right to use any of the images taken for publicity, promotion, or other purposes, such as entering the images into print competition. Often companies that make standard business forms like NEBS (New England Business Services [www.nebs.com]) offer forms specifically designed for various professions, such as studio photographers. These forms will often include such

Ralph Mendes' promotional cards, which he sends out as reminders to juniors and seniors, exhibit the excitement offered at his Riverside, California studio for senior students.

a clause. If, however, you use someone's image as part of a direct-mail or advertising campaign, it is a good idea to get a second release specifically worded for the intended use of the image.

Posting Proofs on the Internet

All of Rick Pahl's senior images are digital. He involves the seniors in the process by showing the just-taken image on the camera's LCD screen. He finds this provides valu-

able feedback in posing, and it sets the stage for seeing the finished images.

Pahl "works" all of the images in Photoshop, adjusting lighting, backgrounds, skin tones, and completes the all-important retouching. The clients go through the preliminary images and help cull the final take down to about thirty. "Once we have the images selected, one of our people will write up the order on the spot and collect the money at that

time," says Pahl. "Clients are very excited and, as a result of this instant feedback, they purchase freely.

"Because of a great tip we got at the last WPPI convention, we avoid posting [proofs] on the web, as the clients can get 'satisfied' by looking at those images and not purchase anything. It happened to us once and we couldn't figure out why we had no sales of a family reunion shoot. After we heard that tip, we knew why."

Senior Albums on Display

When seniors come to Larry Peters' studio for their first pre-session appointment or for their actual portrait session, they can look through albums filled with great senior portraits, featuring the great variety of looks the studio offers. According to Peters, the albums seem to have cast an irresistible spell on seniors, who will look until they have to move on. Peters constantly changes the images and updates them with the latest studio offerings.

Senior Contact and Follow-Up

Ralph Mendez, a successful senior photographer from Riverside, California, strongly believes in his quarterly newsletter as a means of keeping in touch with his senior clients. For every session and purchase, a thank-you card is sent to acknowledge his clients, and all seniors receive a graduation card.

Senior Photo Exchange

Seniors love to exchange their photos with one another. It's part of memorializing and remembering

their senior years. As part of your basic package, you can increase the number of wallet-size prints or "locker-size" prints (4x6 inches) to accommodate this need. Or you can offer special reorder rates to give seniors the option to add on.

Student Representatives

A senior representative is a junior whom you select to help promote your studio in his or her school. The first task is for the student to gather the names and addresses of other junior students so that you have some kind of mailing list to work from. Studios should promote themselves to every junior whose name and address they can obtain. Names are gathered via sign-up sheets or a coupon offering a discounted session fee, the bottom half of which is an address section. With a list, albeit a partial list, you can begin a direct-mail campaign. The student reps are paid (in cash or discounted photographs) for every accurate name and address they

bring in, usually when that student places an order.

Larry Peters calls his student rep program the "Ambassador Program." He uses it to draw business from a school in which he has never worked. He finds student reps by advertising in the classified section of the local paper and says that the more outgoing and popular a student is, the better "ambassador" he or she will be. Of course, knowing a teacher or faculty member is the best way of locating student reps. Peters also recommends calling the parents of every student you plan to use for the rep job. It is the courteous thing to do, and parents will often check up on the status of their "ambassador's" job.

If your area is big enough and you have enough student reps from the various area schools, it is often a good idea to have an orientation for all of your reps. You can answer all of their questions and give them the best sales techniques for obtaining a qualified list.

Ellie Vayo lists her student representatives on the senior page of her web site (www.evayo.com) along with e-mail links and phone numbers of their reps.

Above—Cubberly Studios' award-winning video is reprised on the company web site as a Flash/Shockwave animation with great audio and fast-moving images. **Facing Page—**This is a Fuzzy Duenkel portrait prepared for print competition. Combining the beautiful shapes of the violin and the similar shapes of the senior girl's face and very symmetrical hair, Fuzzy created a timeless portrait that will be appreciated on many fronts.

Video Marketing . . . and Then Some

High school seniors are a tough sell. In these days of MTV and the web, you have to do more than get their attention, you have to grab it. But how? Cubberly Studios (there are four of them in Ohio with a total of forty-eight employees) found a way to win seniors' attention—not to mention an array of marketing excellence awards.

"It all starts with one theme," explains Cubberly photographer Brian King, the creative eye behind the award-winning senior campaign. "Establish one concept of communication, and once you find your main theme—your overall message—weave it through everything you do."

In its current campaign, Cubberly uses a ten-minute video as the catalyst. According to King, "The video is quick and energetic. It has a feeling that says, 'we're competitive.' The kids are sold by the excitement and mystery generated by the obscure and fleeting images. We presented this video to our schools and communities, and then followed up with a series of four direct-mail postcards designed to continue the theme established in the video. Our Studio Session Guide, which includes a wealth of information for prospective senior customers, uses the same graphics and theme as the video, so identification of our studio is reinforced. The same theme and graphics are used in all the follow-up postcards. Everything seniors receive from our studio looks, feels, and communicates the Cubberly mission statement before they even read a single word. That's how we get the most out of our marketing."

The web site also features the same graphics as well as a Flash-video presentation that reprises the ten-minute video in high-tech Internet fashion. All of the graphics for the campaign were designed by Rod and Sheila Farley.

Wallet Special

In the winter months, well-known senior photographer Larry Peters' studio business grinds almost to a halt. This promotion capitalizes on graduating seniors needing wallet-size photos to include with their graduation announcements. The special applies to previously ordered negatives. The profit margin on a promotion like this is low, so Peters groups the negatives and ships them off to the lab for package printing. He always comes up with a catchy slogan that goes out to graduating seniors. One such promotion reads something like "Are your friends threatening to tie you up unless you give them the wallet-size photo you promised?" It also includes the offer of "big savings," which it is, and as always, includes an expiration date.

Yearbook Advertising

Studios looking to pick up more senior business might wish to purchase a full-page ad in school yearbooks. It's an investment that's relatively inexpensive, but will pay big returns. Seniors see it. Juniors (soon to be seniors) see it. Families see it. This is direct marketing at its best.

Ralph Mendez, a well-known Southern California senior photographer, uses yearbook advertising as a part of his marketing budget. Ralph's half-page ads feature a junior girl. When that junior returns to

Web sites are the way to go with seniors. Ralph Romaguera's web sites (above) include a friendly gallery of images so seniors can get an idea of the great variety of imaging services the studios offer, as well as great tips and a frequently asked questions section that details virtually every concern a senior might have about their photo session. Jeff Smith's web site (left) is so complete, it not only shows images made at the various park locations Smith frequents for his senior portraits, but it also gives detailed directions on how to get there.

school for her senior year, she is instantly recognizable as a local-area senior.

The "You Ought to Be in Pictures" Promo

Frank Frost, a well-known senior photographer from New Mexico, says, "Photography of seniors makes up a nice portion of my business. Recently we negotiated with United Artist Theaters, one of the largest in our area, to cooperate on a 'You Ought to be in Pictures' campaign, complete with in-theater advertising and freebies from the theater. I also target seniors with a four-color referral card worth twenty dollars in studio credit for referring a friend. Senior mailers in the form of popcorn boxes, complete with microwave popcorn, are currently being produced, and participating seniors also receive theater tickets."

Window Dressing

Studios sometimes create 24x30- or 30x40-inch prints for their display windows. Great display prints generate walk-in trade and excitement among potential clients, especially when the same image is used in current promotions or advertising.

*T*here are as many ways to sell photographs to seniors as there are seniors, but usually it works like this: A nominal session fee is charged and it covers the photography and ensures a set number of poses will be created, usually with several changes of clothes, backgrounds, and/or locales. In addition, the session fee usually includes a certain minimum amount of retouching. However, specific retouching requests, like removing braces, cost more. Similarly, any kind of computer enhancement is usually extra, depending on the studio.

Session Fees and Types

There are various session types available. For example, Cubberly Studios in Ohio offers five different sessions, each with different

Frank Frost does a lot of location senior portraits that seem to please his senior clients. Location portraits may be part of a standard package or part of an add-on to the basic senior package—it depends on the marketing strategy of the studio.

Above—Most kids don't want to be photographed with braces. Many studios will remove braces for an extra retouching fee. Photographs by Ira Ellis.

Facing Page—Part of the mystique of having your portrait made as a graduating senior is that it can incorporate the things that make you unique as a person. This graduate from a private prep school has a serious interest in history. Often an initial portrait session will lead to a special session like this that involves elaborate props. Photograph by Ira Ellis.

features. The Classic Session, a traditional session, includes head-and-shoulders and three-quarter-length poses. It also includes two different outfit changes. The Contemporary Session features two different studio sessions (with two different outfits) and an outdoor session (with a third outfit). The Contemporary Session is the studio's most popular session because it offers the greatest variety and the session fee is still quite nominal. The Black and White Session is a studio session with dramatic lighting and a "fine art" approach. This one is also popular and seems to render the best "personality portraits," according to Brian King, one of Cubberly's top photographers.

The Best Friends Session features a second person or significant other. "You can even bring all of your friends," the brochure states. The Town and Country Session is a designer session comprised of the elements in the Classic Session, plus the opportunity for location shooting as well. The session fee for the Town and Country Session is nearly five times more expensive than the others and requires a fairly hefty minimum print order.

Photographers' session fees will vary by the amount of exposures or poses made. Some will vary by the amount of time allotted to the session. Almost everyone calculates their fees differently.

Ellie Vayo has seven different senior sessions and lets clients mix and match from any of them to get the perfect session. Ellie's On Location Session includes twenty-four to thirty poses, including ten indoors at the studio and the rest on location within a ten-mile radius. The total time frame is about ninety minutes and includes up to five outfit changes. Her Senior Plus Session is designed for the senior girl and includes a makeup application in-studio and thirty poses with a variety of indoor and outdoor poses. This too is a ninety-minute session and also includes five outfit changes. Her Black & White–Color Combo Session includes up to

Fuzzy Duenkel's session fees are higher, as a rule, because of the three or more hours it takes to photograph each senior. He is intent on providing original portraits of his seniors in locales that mean something to them. To do that, he must often travel and spend quite a bit of time optimizing the lighting at each unique location. Every Duenkel session of a senior girl is preceded by a makeup session at the studio. Then it's off to the location—either the student's home or a meaningful locale nearby.

Acclaimed senior photographer Fuzzy Duenkel has a contrasting strategy. His pricing structure of a high session fee with low reprint prices has yielded great results for his studio.

Often photographers will discount session fees in order to book bodies into time slots, knowing that the bulk of their profits will come from print and package sales.

Liability Waiver

Jeff Smith, the well-known Central California photographer, does a lot of location shooting. One of the beauties of his senior portraiture is that his locations are not manicured parks, but usually out-of-the-way, rugged and beautiful environments. He also photographs seniors at dusk and even at night (he calls them "nightscapes"), when it is sometimes difficult to see when photographing with strobes. Although he is always careful, Jeff has each senior parent sign a liability waiver for these sessions where the risks are greater and more varied.

Pricing

Package Pricing. Package pricing includes a certain minimum number of prints; for example, a particular student might order a promotion that contains two 8x10-inch prints, four 5x7-inch prints, and sixteen wallets. You can always add to the basic package. For example, you can add a 20x24-inch wall print or ninety-six wallets and pay the base package price, plus the cost of the additions. Premium packages are often custom-designed packages that in-

eighteen color indoor and outdoor poses plus up to six black & white poses. This session lasts one hour and includes four outfit changes. She also has four more sessions that are variations on those discussed above and involve different times, number of outfit changes, or total number of poses. In each case, the session fees are quite reasonable.

clude the minimum package order but with exotic add-ons like large framed wall prints.

À-la-Carte Pricing. À-la-carte pricing lets you assemble any size and number of prints available from the studio's price list, without being tied to a basic package. For example, if all that a senior wants is "locker prints," then that is all he or she has to order with à-la-carte pricing. If all a family wants is a 30x40 canvas-finished print to hang over the mantel, then they don't have to take the minimum number of 8x10s and 5x7s from the package. The à-la-carte menu features different prices for different size prints.

Special Offers

Often a studio will offer a real bonus value as an alternative to package- or à-la-carte pricing or as an incentive to purchase a certain premium pack-

Signature type composites are not usually a standard part of a senior's portrait package but may result from a consultation meeting. Here Richard Pahl has put together a first-rate action composite of a budding tae-kwan-do star, using the athlete's patch as a background for some first-rate action shots. All of the shooting involved in this composite was time-consuming and hopefully profitable.

A team composite that goes way beyond the "sports" photos made by contract photographers in years gone by is one in which Larry Peters combines every member of a high school basketball team en route to a dunk. The original images are done on a Hasselblad with a Phase One digital back, so that image files can be layered into a Photoshop file for compositing. Can you imagine a single member of the team not ordering one of these?

One of Larry Peters Studios' specialties is the senior composite, which involves five or six stylish shots of the senior combined with a stylized type treatment of their name and usually a close-up image. In this composite, Peters combined a close-up of Heather's eyes to "peer over" the rest of her portrait images.

age. For example, Cubberly Studios offers the 4x5-inch proof prints packaged in an album and sold at a very reasonable price. The studio doesn't want to keep and store the proofs, but doesn't want to give them away, either. The Proof Album, sold at a discounted price, allows the studio to get rid of proofs profitably. A canvas-mounted print is another example of a special offer. It may be sold below cost as an enticement to "order up" to a more costly package or for ordering one of the studio's premium products.

Finish Differences

Another difference in pricing stems from the finish of the print, the type of paper it is printed on, and the artistic treatment of the print. Cubberly Studios offers five different premium finishes. The Artisan Series offers the original image toned in sepia and printed on a warm tone paper. The resident studio artist then adds transparent oils to add color in selected areas of the image. The Canvas Finish gives the print the look and feel of artist's canvas. The image is actually bonded to a high quality artist's canvas and then sealed in a glaze, preventing the need to frame the image under glass for protection. Canvas Finish prints are often sold in the largest sizes for wall mounting. The Watercolor Finish at Cubberly's Studio features the original image printed on Arches Watercolor paper and then enhanced with artwork to create a subtle watercolor effect. The Fine Art series is what the studio calls a dynamic style of black &

Robert Love produces beautiful senior portraits that almost demand that a large beautiful wall print be ordered.

white portraiture. Each image is printed on archival fiber base papers. The Classic Finish is a fine quality print that receives artistic enhancement of the negative and print. The print is then adhered to artist's board for support and strength and is glazed with lacquer. In addition, most studios offer custom framing options for premium prints.

Deposits and Prepayments

Most studios require a hefty percentage of the order to be paid

beforehand as a deposit on the total balance of the order. In addition, to combat thievery via scanning when the proofs are taken home, some studios require that the customer pay a security deposit if the proof prints are to be removed from the studio.

Proofing Session

One way to guarantee that you will see your clients again is to not deliver proofs, but instead to invite them to the studio to view projected proofs. You can project the images onto a screen or wall or even into a frame (with a white background) that would be complementary to the furnishings of the average area family's home.

For this type of proofing session, you need the negatives made into slides. Many labs offer this service, calling the slides made from negatives Transvues. There are also video projectors available, but you must first have the proofs transferred to video.

Other photographers, like Rick Pahl, prefer to have a "proofing session" in the studio, with the clients seated at a big monitor. The images, at this point have all been "worked" in Photoshop—retouched, color corrected and, in some instances, a creative effect or background added.

Another way to preview the images is by using Kai's Power Show, a presentation program that allows a CD to be written of all the proofs. The proofs are presented in an attractive slide-show format. The CDs can be sold at a later time as part of the package price. This is a feature that Riverside, California senior photographer Ralph Mendez offers. Microsoft's PowerPoint is another useful program for proofing images in a slide-show format.

Another means of proofing is with the Kodak ProShots system, which is a suite of tools that help

Facing Page—Brian King of Cubberly Studios creates the kind of senior portraits that please both the parents and the senior. The studio offers a wide array of treatments and finishes for the families to choose from—in all sizes and price ranges.

you post your senior proofs online. Some photographers print the Pro-Shots preview sheets in-house for order selection. These don't leave the studio without an order advance. ProShots also has the advantage of allowing you to design a senior album using any of the hundreds of templates available on the system, much like wedding photographers do to preview the wedding photographs and album.

Fuji has a similar system called Studiomaster Pro. Both systems are designed to save time and increase productivity, and while primarily designed for the wedding industry, they both have applications for senior portraiture.

Fuzzy and Shirley Duenkel: It's All Happening at Home

Fuzzy Duenkel is one of the most innovative senior photographers working today. He has a unique attitude toward what he does—he wants to satisfy his own creative needs and not just make money. He believes the ultimate in portraiture rests in the notion of personalization. He has created a thriving senior business by doing what comes naturally—eliminating the unnatural and replacing it with what is real—the natural environment of his senior clients, sloppy rooms and all.

Fuzzy is the ultimate perfectionist, his quest being the creation of the perfect photograph, a dream (obsession) he has had since becoming a professional photographer in 1975. Fuzzy does all the photography and his wife Shirley handles everything else, which includes consultations, sales, and order processing.

Here, in his own words, he describes the metamorphosis toward personal success as a senior photographer.

"As our focus switched from weddings to portraiture, I began photographing high school seniors in and around our town. I searched for interesting but often cliché locations—alleys, railroad tracks, parks, interesting architecture, and scenic vistas. It was fun, but after a while it became boring for me to go to the same locations. We tried instituting a rule that I wouldn't go to the same location twice in a year! I realize it was the first time for that senior, but it wasn't fun or original for me. Plus the photographs started to look like copies of their friends' pictures.

"After years of scouting locations, I became aware of the wealth of portrait possibilities in people's yards. Most of the time the best yards are not necessarily at new or wealthy homes. The kind of character I enjoy is mostly found in modest, established yards and farms. Mature shade trees, tall grass, and front porches make excellent portrait settings.

"So in 1999, we began the session at our studio for makeup, then the senior and I would go back to their homes for all or part of his/her portrait session. This has been one of the most exciting changes in our photography.

"I take it as a personal challenge to create dramatic, artistic, and unique images in 'ordinary' places. Most of the seniors I

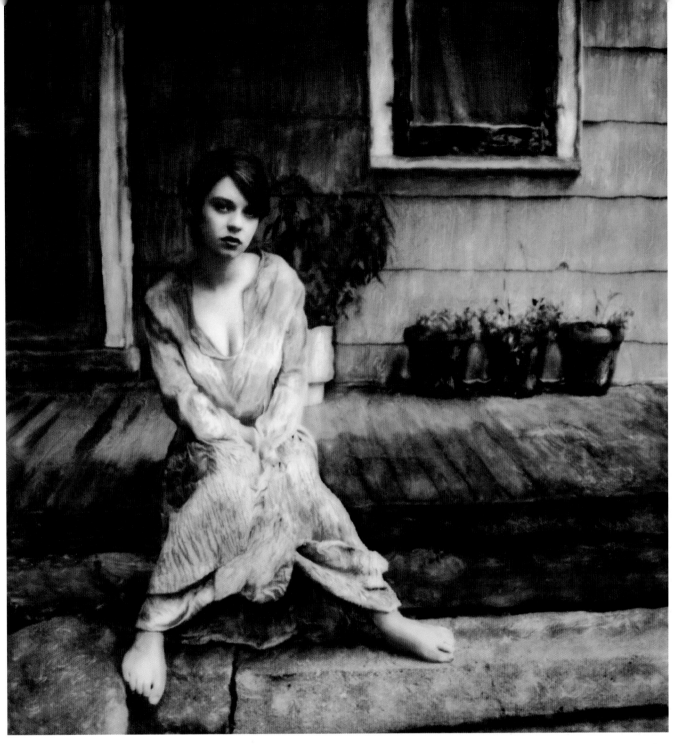

photograph live in very modest, middle-income homes. Understandably, many are reluctant to have me come to their homes because they don't think they have any place worth photographing. While they may not have a spiral staircase, an in-ground swimming pool, or a meadow in their backyards, every home has unlimited portrait possibilities! The longer I do this, the more I learn how to discover portrait locations that, years before, I wouldn't have known were there!

"We tell the seniors that I'd rather go to their homes, so I better be able to deliver the goods! I realized that I needed to come up with ways to do extraordinary work with the ordinary settings we have here in the Midwest. It meant learning how to see what *can be* rather than what *is*.

My job is to change the literal into an interpretation.

"As a photographer, I have to be open-minded to all opportunities that present themselves. I have to take what I'm given, and follow its lead. The location will determine whether the image will be best in low, medium, or high key; whether to use wide-angle or telephoto lenses; if I should add or take away light;

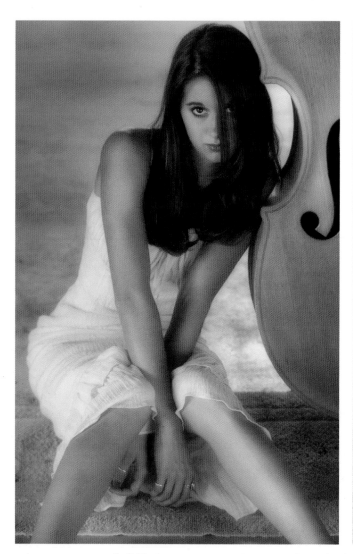

what amount of diffusion to use; whether to vignette; which pose was best; and if the subject should be full-length or close-up.

"Again, the house and the existing lighting dictate the rooms to use. I've photographed seniors in attics, bedrooms, halls, lofts, living rooms, dining rooms, kitchens, bathrooms, stairways, basements, breezeways, garages, and barns.

"A good exercise is to look at your own home and select areas where you would photograph a senior. I expect that most of us think our own homes are ordinary and without artistic portrait locations. That's the way our clients think too. They think their typical, middle-income, three-bedroom house with a beige living room and decorative trinkets on the walls has nothing to offer. Of course, that's nonsense! Don't think about the literal room and what you see, but what a camera could see. Study possible vignettes. Look for light. Imagine what a small background area would look like out of focus. Consider different camera angles.

"My motto is, 'Use whatcha got, and quitcher complaining!' We don't have Spanish arches, cascading gardens, or mansions in our town. Wisconsin has farms, plain three-bedroom houses, simple architecture, small towns, country roads, Lake Michigan, rivers, and smaller lakes. So that's what my photography reflects. If I lived in another part of the country, the senior portraits I do would look different, reflecting that local style.

"Here comes the hard part. Take an honest look at your senior photography and ask yourself if what you do would look exactly the same in another part of the country. If you're using studio props and commercial sets, the answer is, 'Yes.'

"My ultimate goal is to create portraits that tell a story, create a mood, or express that person's character. I'm able to do the first two, but capturing a senior's personality is the most difficult challenge we are asked to do. What I *can* do is put my

whole self into every image I make. As the 'author' of the story I want to tell, I can express what I feel, and combine that with the perceptions I have of the subject, using the photographic tools I know. I admit that my portraits are more often reflections of myself than intimate portraits of my subjects. However, at least I can say the portraits I create are more real because of the location. How can pictures of a senior in a studio set, where a few hundred other seniors stood, be 'real' and personal? Going to a senior's home is a giant leap forward in photographing him or her as a real person.

"In addition, going to their homes has made clothing selection like finding a treasure chest! No longer do I wish the senior had brought the right outfit. When I get to their homes, I go into their closets and yank out solids, dark clothing, light clothing, long sleeves, coats, etc. All the clothing they say

they don't have, they do! They just don't realize their old clothing is already perfect.

"Seniors are usually given freedom to decorate (or mess up) their bedrooms the way they want. That gives me a huge clue to the senior's personality. The range in bedroom decorating styles varies from boring to bizarre. And that helps me to know what I need to do for them. I actually find it easier to do at their home than in the studio. I get inspiration from the location.

"Let me address the obvious issue of the enormous amount of time I invest in a senior session. It varies between three to six hours, with travel. Now, you may be thinking, 'I don't have or want to take that amount of time to drive to their homes.' Well, I understand that what I do may not work for many photographers. Those who have chosen to do more seniors, hire employees, have a studio with high

rent or multiple studios need a more cost-effective portrait production to maximize profit per time consumed. But that is a consequence of your choice to expand your studio operation. And that choice means resorting to commercial props and backyard portrait parks, which also means you give up the ultimate in personalization. Sure, it is possible to change the way a prop is used for each senior. But more often than not, those are merely photographers' ideas of variety.

"Here's a novel concept: Because I can only do a limited number of seniors this way, it opens the door to more photographers to do the same. Wonderful! We don't have to greedily try to grab every senior that has ever existed. We can all slow down and be the portrait artists we wanted to be when we first started in this profession. And this can only help the public's perception of senior photographers in the long run."

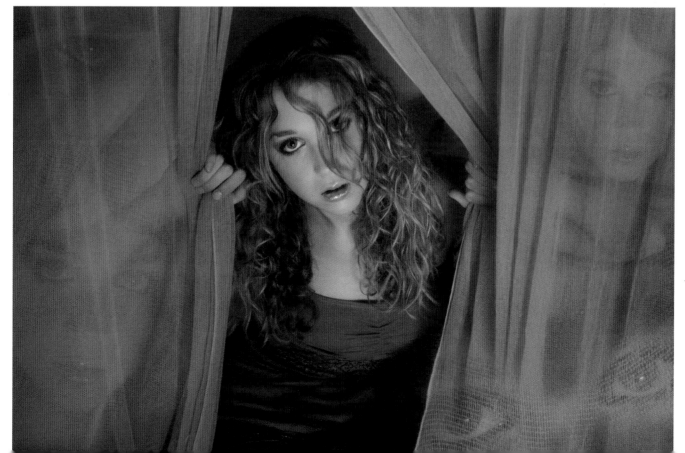

Jeff Smith:
Reinventing the Senior Market

Jeff Smith owns and operates Jeff Smith's Photique in Fresno, and Monterey, California. The studio has its own web site, which features articles by Smith and other information important to seniors.

In the Central California area, according to Jeff Smith, a great many studios have entered the senior market, all of them trying to get a bigger slice of the senior pie. Smith says, "Studios have become well educated in the ways of marketing, advertising, and promotion, to the point where there is little left to promote, other than the fact that one studio is willing to give away more than another to get the business."

Jeff Smith's studio contracts with eight local high schools and markets to a good number of the area seniors whose schools the studio does not

contract with. His studio photographs almost 2,000 seniors a year.

Unlike many studios that contract high schools, Jeff Smith loses very

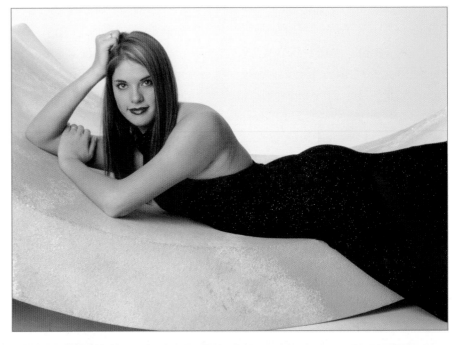

Chelle

ASHLEY

few seniors to other studios. He says, "Years ago, I made it my goal to offer seniors anything they can get from any other studio in our area . . . and more." Seniors who come to his studio can select from more than 260 different backgrounds, sets, and projected backgrounds. They have unlimited clothing changes, black & whites if they're so inclined, and can include friends, cars, and motorcycles in their images—and all at no additional cost. "The most important option that seniors have is the ability to go to outdoor locations—there are beautiful scenic locations all over the valley where we live," says Smith.

The biggest problem, however, is travel costs. "With many of these locations thirty to forty minutes from the studio, a sitting fee of $100 to $300 would have to be charged just to cover this loss of time."

To overcome this problem, Smith and his wife, Charla, decided to schedule two seniors at a time for each location. This arrangement works nicely for both parties: Jeff can work through the downtime encountered by many photographers by photographing one subject while the other is changing his or her outfit. (This is a practice Jeff routinely uses in the studio.) Additionally, this solved the prob-

lem of travel expenses, because the cost could be divided between ten to twenty seniors.

When he first started offering seniors outdoor photography, Smith had a hard time finding outdoor locations that were worth traveling to. Most of the local parks were well groomed and didn't have the natural look Smith wanted for his senior portraits taken in three-quarter- or full-length poses. He suggests, "As you start to look for unique places, look at natural water areas. Rivers and natural lakes have well established foliage and are more natural in appearance, not to mention the possibilities of including water in the

scene. There are also many unique private parks and gardens that are available to rent for parties, weddings, and other events. Amusement parks, theme parks, or public children's story parks also make interesting settings."

Many seniors today want outdoor portraits, but they prefer more of a street scene—graffiti-covered overpasses, railroad tracks, abandoned warehouses or older buildings can all provide an outstanding setting to create portraits that reflect the tastes of your senior clients.

The senior market is always changing. Backgrounds and sets that worked five years ago, make today's seniors laugh. Outdoor portraits have a broad appeal to seniors—it's a style that never goes out of style.

Ellie Vayo: Customer Service at the Highest Level

Ellie Vayo is a well-known senior photographer with a marvelous studio estate in Mentor, Ohio. As you have seen throughout this book, she is a marketing superstar, having won numerous awards for her out-of-the-box marketing style. She is also all about customer service, as you will see by visiting her web site.

It's been twenty-five years since Ellie Vayo started her company. Although it started out small, Ellie Vayo Photography Inc. has now grown to be one of the largest, most successful senior portrait studios in the country.

The studio has five full-time employees and many part-time employees needed for special functions. Ellie employs three in-house makeup artists because the studio specializes in glamour portraiture, boudoir, and especially, high school senior girls.

The studio, built in the 1940s, is located in a historic stone cottage about thirty miles east of Cleveland, Ohio. The stone used in this building was all taken from an old breakwall in Fairport Harbor. The 3,500 square-foot area offers the room to deal with more than one client at a time. The studio is situated on a fully landscaped half-acre lot, one mile east of the Great Lakes Mall (in Mentor, Ohio). In the back of the studio there is a park setting, complete with a gazebo, beach, swing, barn, stone waterfall, and much more! It is the perfect place to make senior portraits. There is no need to leave the property to go to the park!

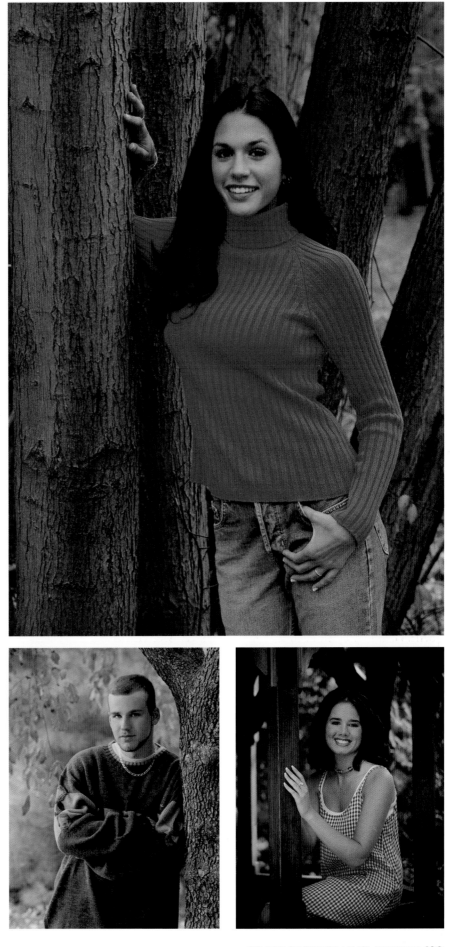

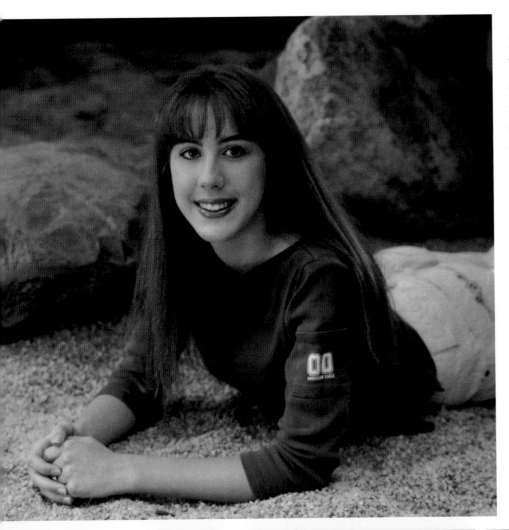

Ellie Vayo recently joined General Products in creating the new "Ellie Vayo Senior Album," which is specifically designed for the senior market. This album is a cohesive sales tool that displays everything the studio offers—from packages, to retouching services, to cluster collages, to announcements. The album has increased the studio's sales tremendously!

Her speaking ventures are also sponsored by such companies as Tamron/Bronica, Buckeye Color Lab, and Fuji Film, making her much more than a Midwest studio owner. She has become nationally recognized as one of the finest senior photographers in the country.

When you view her web site, you will realize she is a caring person who is concerned about the positive and healthy experience she provides her senior clients.

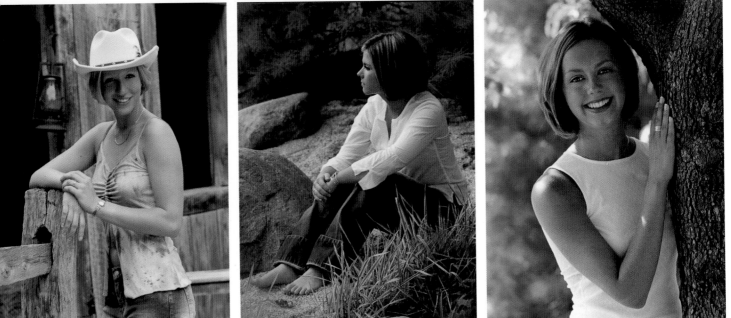

Richard Pahl: 100 Percent Digital, 100 Percent Seniors

Richard Pahl is one of the most successful print competition entrants in the country. He has scored numerous perfect 100s and 99s and has received numerous first-place awards in various WPPI and PPA print competitions. He has written numerous articles for photography publications and has been a featured speaker at annual conventions around the country. Like everything he has ever conquered photographically, senior photography bears his own unique brand.

Rick Pahl broke onto the national scene as a Photoshop expert. Until recently he has been remembered for his digitally manipulated imagery and perfect scores in print competition. Rick spent literally thousands of hours with Photoshop, learning nearly every facet of this powerful program. But he is also an accomplished senior photographer and this probably stems from his love of kids of all ages.

One of Rick's mandates photographically is to capture the beauty and physicality of teens for posterity. He communicates well with seniors and on that topic he says, "I spent a few months recently as a teacher for middle school and some time in our high school (in Okeechobee, Florida). In all matters regarding the 'generation gap,' it is a matter of attitude, both on the part of the elder and the teen. I was a 'favorite' substitute teacher. I met teachers who actively dislike children. Guess who the kids disrespected most?"

Rick and his wife, Kat, pose the seniors, whom he calls his "models." He says fondly, "We treat them as such."

Rick shoots completely digitally as it aids the entire process of photographing seniors. He says, "I have no restrictions as to film rolls, developing and proofing costs, etc. I will shoot, on the average, sixty to ninety images per hour, many of these in sports mode (on the Canon 1D), which rips off a couple of dozen shots in a burst. This helps when the subject's hair is being blown in the wind, or the model is animated. It also gives me reduced control over the lighting, as my flash units can't keep up with the camera. I'll get some frames with half-flash and some without flash—or perhaps one or the other of the two flashes will take the next shot off."

When he knows he got a series of good images, he "light-tables" all of

of storage media, and have a couple of apprentice Photoshop operators, so we can run a lot of images through here in a day. On a typical shoot, we may take 150 shots. We can show the senior his or her shots in five minutes, simultaneously sending the imagery to another computer where the final pictures will be prepared."

Rick shoots with a Canon 1D with a 1GB microdrive, which holds around 300 images in the RAW format, which is all he shoots. He can download the image files to his Mac in a few minutes, erase the microdrive and have another 300 shots available.

Rick Pahl's senior images are full of life and fun. One reason for that is that Rick genuinely likes "his kids." He says, "I really like teens! All the teens I shoot become one of 'my kids.' I've learned that full and honest respect for someone between the age of thirteen and seventeen is essential. I talk to them as though they are adults. I kid with them in the same way. All my kids become part of the year's 'Dream Team,' and a copy of their portrait hangs in a place of honor in our town's best art gallery."

On a shoot Rick lets the kids look at the images on the back of the camera, which encourages them to relax and work with him. It's yet another advantage Rick Pahl sees in shooting digitally. "I do not restrict any of my shoots," he says. "I keep tripping the shutter until I think I've covered the job. If it takes five shots or 150, I don't care. We try to begin at a set point, usually at a time and

the views of the shoot for the client in a great program called I Photo, which is for Macs. "We can select images from a 500-image shoot in five minutes, marking the possibilities as we go along. I can zoom in on each image, demonstrate crops, show them as a slide show—it's very flexible. In a half hour or so, we've moved from the 'possibilities' to a new folder. Still within I Photo, we then go through the same process, except now we're tossing out what the clients don't want."

Once the imagery is selected, one of Rick's sales people will write up

the order on the spot and collect the money at that time. Clients are very excited and, as a result of this instant feedback, they purchase freely.

Rick saves the direct files from his camera on a hard drive, and when the business of selecting images for enlargement is done, nothing is kept on the hard drive except what he calls "the final culls." These are then burned to a CD and filed in a safe place. The other 270 images, roughly, are trashed. Rick says of his workflow environment, "We are fully digital, have three computers in a LAN (Local Area Network), have plenty

place of the subject's choosing, then let the shoot flow. Often I'll see something that needs to be pursued, like a shawl over a girl's head, or a bookworm shedding his shirt for one of the 'beefcake' shots that constantly amaze the females in our little town."

Speaking of Okeechobee, one of the highlights of this town's social arena is the high school graduation. According to Rick, "For about two weeks, the seniors of Okeechobee are treated like royalty. Everyone, and I mean everyone, gets behind these kids to congratulate them for getting through and succeeding. This attitude carries right into our studio. One of this year's graduating seniors, for whom we did a senior portrait session months before, came by to show us her graduation present, a new car. Lots of 'my seniors' stop by to chat with our assistants, who are their age, or just to say hello."

Rick never considers the captured image the final image. "I finish off the lighting of a given image in Photoshop. A fan of Hollywood glamour lighting, Rick will tweak an image in Photoshop until he's happy. He's even been known to add the shadow of a "branch" across the face of his subjects in order to introduce an element of mystery. "I like to play with the images. I like to soften images and have developed a method of making a 'variable' softening effect, so that some of the image may be softened to a degree of 10, while other parts are softened to a degree of 90," he says.

Ralph Romaguera: Understanding the Savvy Senior Market

One of the most successful senior photographers in the country, Ralph Romaguera, who operates three highly successful studios in the New Orleans area along with his two sons, Ralph Jr. and Ryan, is dependent on one basic business tenet: Don't underestimate the sophistication of the senior market.

High school seniors know what they want and like in portraiture, and this generation has a keen eye for what's hot and what's not. "Offering a lot of possibilities, both in the studio and on location, is very important and we are constantly trying to change the look of our senior portraits to keep up with what seniors want," says Ralph, Sr. He believes the portraits have to be fun, exciting, and hip, and his studio strives to the "hippest" studio in the area. This philosophy is paying off, and Romaguera Photography now photographs an average of 1,500 senior portraits annually in addition to the three studios' thriving wedding and portrait business.

Ralph Romaguera is successful, and his reputation is international in scope. Much of that success, especially in more recent years, can be attributed to the growing senior business, and it is a segment that his studios target with special attention.

High school seniors are Internet savvy, something that has not been lost on the Romaguera team. In conjunction with Marathon Press, Ralph, Jr. has created an attention-getting web site that in 2001 won the Senior International Web Site of

the Year Award from Senior Photography International, a Florida-based organization that is dedicated to this market (www.seniorphotog.com). The Romaguera site provides a range of information and a gallery of photographs that not only highlight the quality of the studio's work but also encourage potential clients to be involved in all the planning of their portrait session. Says Ralph, "We try to give as much information as possible so the seniors and their parents know what to expect and

plan for. The more information they have, the better their session will be."

The web site gives information on virtually everything that the senior will encounter in his or her portrait session. Topics such as what to wear, how to coordinate various outfits, eyeglasses, props, senior rings, tan lines, punctuality, friends, pets (no snakes, please—according to Ralph there was an unfortunate incident once), zits, braces . . . the list goes on and on. The benefit of providing

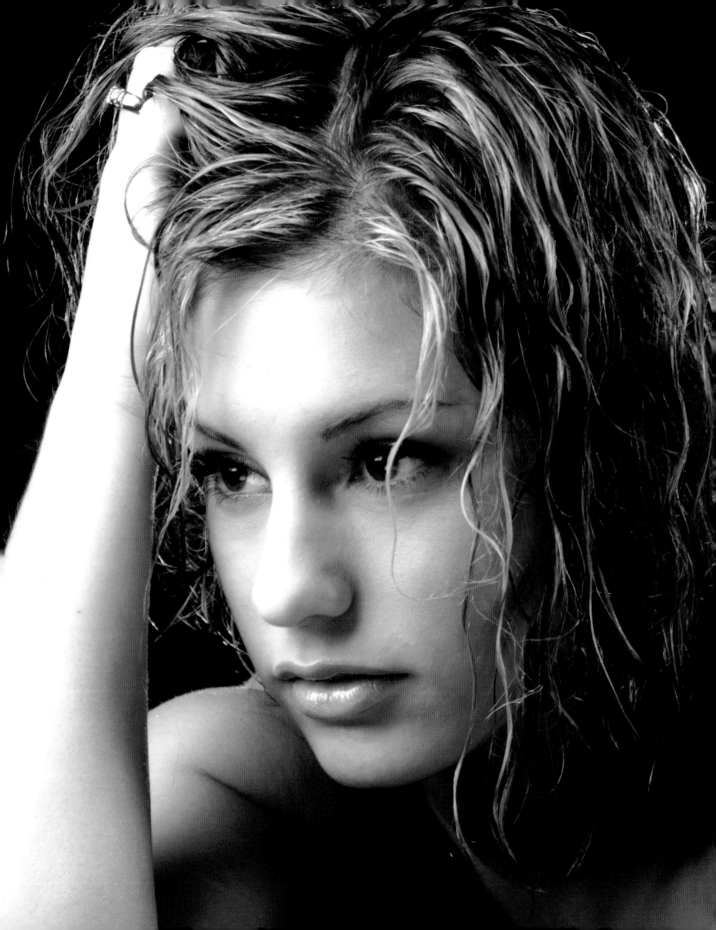

such comprehensive information is that much of the anxiety that goes with the senior-portrait experience is removed when the students find answers to their most frequently asked questions. Also, when they see the answers to questions they themselves had, they correctly assume that many of their peers have the same questions.

Ralph feels it is the studio's job to make the kids comfortable with the session and to make sure they feel part of the whole thing, from selection of props, to location and background. Romaguera Photography

treats the senior session as a big part of the senior's life experience and tries to make it as special as possible. Ralph says, "Seniors are savvy clients who know what they want. They also make the best referrals. Seniors tend to shop around and compare products, so while we have a large portion of the market at present, we have to stay on top of it to retain or expand our share."

All Romaguera Photography's senior work is shot digitally, and the studio uses Kodak DCS digital cameras and a Kodak LED printer. The company's own digital lab is located at their Matairie, Louisiana office, and files are sent via FTP (File Transfer Protocol) to that location for retouching and printing.

The Romaguera stamp of quality goes beyond the production and delivery of photographs into the often-overlooked area of client education. Such things as preservation of portraits, what services to expect, fees, delivery times, and copyright matters are all covered in information offered on their web site.

Ralph Romaguera is successful in the senior market because he offers the highest quality images to his customers and because he treats seniors like preferred customers, believing that an educated client is usually your best client.

Deborah Lynn Ferro:
The Artist's Touch

Deborah Lynn Ferro is an artist by trade (watercolors and pen and inks), but seven years ago she was asked by her daughter to take some pictures for *Sports Illustrated*—and they needed them in a hurry. She grabbed her birthday present, a Canon Elan, and felt immediately at home with her eye to the viewfinder. The pictures impressed both mother and daughter, and since then Deborah Lynn has been on a whirlwind educational tour, learning from some of the top masters here and in Europe, refining her photographic skills, and developing her Photoshop skills as well.

Deborah is excited about working with seniors, something she is very new at. She loves their energy, enthusiasm, and nonconformity to the traditional yearbook pose, allowing her to photograph them in a more contemporary fashion that is more her style. She says, "Between the ages of thirteen and eighteen, seniors are going through so many emotional and physical changes. We see so many kids during that time in their lives with braces, blemishes, and imperfections that can create a lack of self-esteem. With the ability of digital retouching I feel privileged that I can change a young adult's

attitude and excitement toward getting their photograph taken.

"I not only photograph in the studio but also like to photograph them in their own environment. By going to their environment, whether it's their bedroom, school, or at an extracurricular activity, I am able to capture their personality and include in the photograph the elements that are most important to them.

"Kids today are influenced by magazines and television ads and want their images to look like that. One of the techniques that I use to get seniors comfortable with posing is to show them my posing book. It consists of ads from magazines like *YM*, *Seventeen*, *GQ*, and *Glamour*. I clip out my favorite poses and put them in sheet protectors in a three-ring binder. By showing this book to them, I am able to get them into a pose that is more fashion-oriented than the traditional stiff poses that they are used to.

"Music CDs of current hits that kids love will relax them and get their minds on having fun and less on performing. Recently I showed one of my senior girls a Brittany Spears CD cover and we were able to get her to pose just like Brittany. I also have drinks and snacks available to make them feel comfortable.

"Some of the images shown here are from my latest senior session where eight senior friends came to our studio for a complete 'Photo Shoot Party.' Instead of them coming individually and being nervous about getting their photographs taken, being with their friends gave them an opportunity to observe and encourage each other. Some of my best ideas come from the kids themselves. With that session I included a complimentary group photo from the Party Session for each senior. It is to our advantage to give each senior a complimentary group photo to show around school. They then become our best advertisement.

"I also recently photographed a 'Birthday Senior Session,' where the client with the birthday included her two best friends in the photo session. She was having her friends over for a slumber party and the first part of the evening was spent at our studio and included makeovers, clothing changes, and individual and group photographs. Because I am also trained as a makeup artist by Chanel Cosmetics, I am able to help young women apply their makeup and feel better about the photo session.

"All of my senior work is captured digitally with my Canon 1D. I stop

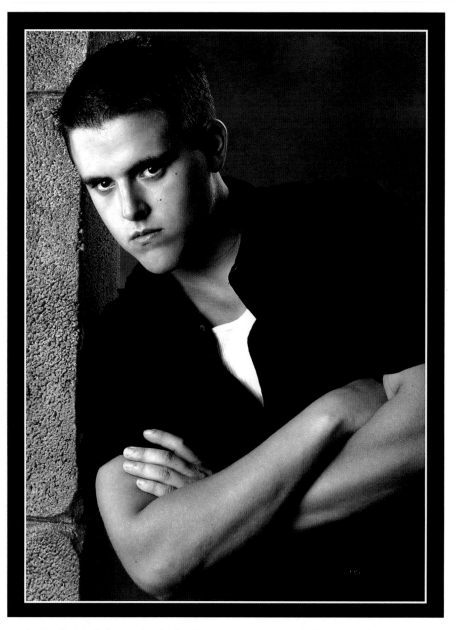

periodically and show the kids their images, which excites them even more. In showing them my work I explain to them that only half of the process is capturing the image and the other half is to transpose the photograph artistically in the computer using Photoshop."

Deborah is also an accomplished and enthusiastic digital artist. "Some Photoshop techniques, as seen in my images where the images look overexposed, can accomplish several goals. By overexposing the image through Photoshop's Levels adjust-

ment, very little retouching is needed, and it makes the image more dramatic. I also love to use Photoshop's crosshatch filter (found under Filters>Brush Strokes) to give a very artsy, painterly look to the photograph. I then apply a photo edge treatment either through Extensis Photoframes or by using Photoshop 7's frames. You can find these frames by clicking the black triangle at the top right of the actions palette. At the bottom of the list is a set of actions called "Frames.atn"—just click on the name to load these

frames into your actions palette. I then print the image on Epson Archival Matte Paper using my Epson 2000P or 1280.

"Another cool Photoshop effect that is loved by seniors is posterizing the image through Filters>Artistic Poster Edges. When applying a posterizing filter on the image you do not want to distort or darken the facial features. As seen in some of these images I went back and erased over the face and exposed body parts, leaving the posterizing filter on everything else in the image.

"Using Photoshop 7's styles palette it has now become even easier to add cool effects to your senior portraits. Click on your option arrow to the right of the Styles folder, and click on Text Only. You will then be able to read all of the styles available to you. To add additional styles, go down to your options menu to the heading Load Styles. You will get a window that gives you an option of styles and you will have to load them one at a time. After you have loaded the styles, you can then apply everything from a drop shadow or background texture to a cool color filter in one click of the mouse.

"Combining images in a collage is extremely popular among seniors. I also offer an 8x8-inch Classic Folio (from Albums, Inc.) called a Senior Signature Portrait Album. All the pages are white with the left side left blank for signatures and the right side with an image of the senior. The senior then has more space for signatures and special messages than their yearbook offers them. It also is a great opportunity for them to show off all their unique portraits."

In speaking with Deborah, she mentioned a boy she photographed who was so self-conscious about his complexion that he almost didn't show up for his appointment. Deborah reassured him it was nothing to worry about and performed her retouching magic on his stylized prints. When he picked up his prints, you could see the joy spread across his face as he seemed to grow two inches with delight. Therein lies one of Deborah's chief joys about photographing seniors: She can bring great happiness and satisfaction to her young clients, and with her skills as an artist and now as a photographer, she is quickly garnering a national reputation as one of the top senior photographers in the country.

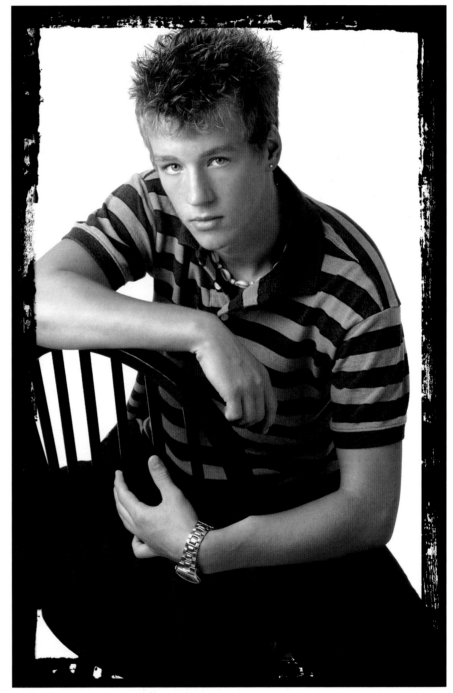

Michael and Pamela Ayers:
The Senior Album

Michael and Pamela Ayers' unique albums chronicle "one very special day" in the life of a senior. These "Day in the Life" albums are highly personalized. Before the session, Michael asks the senior to think of all his or her favorite activities, such as horseback riding, swimming, skiing, barbecuing, picnicking, and even simple things like playing the guitar or reading. All of these facets of the student's personality get woven into the album treatment.

To get these personality-filled portraits, Michael and Pamela become part of the senior's family for a day and photograph a few hundred digital images in the course of several hours. As they visit the student's home (and even school or favorite haunts), they come up with a composite of the senior's day. No image is insignificant, as it may later work its way into the album. Often, formal portraits serve as centerpieces for the album. These may involve a trip to the studio, or the team can bring along lights to the senior's home so that studio lighting can be recreated on location.

The pricing for complete services start at $1,500, but many families spend $3,000 to $5,000 to get additional albums (sometimes in smaller sizes), wall portraits, and gift folios for relatives and friends.

The Ayerses are excited about their childrens', families', and seniors' "Day in the Life" albums. Michael says, "We feel this will soon become our biggest profit center ever!"

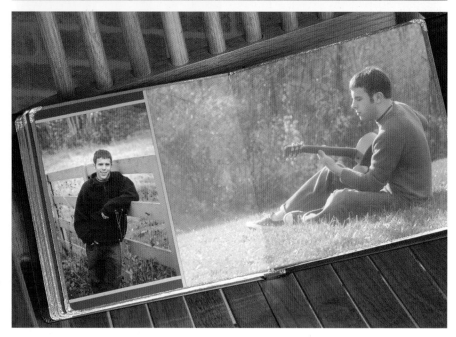

Active posing. A form of posing where the photographer isolates a pose from a flowing movement.

Angle of incidence. The original axis on which light travels. The angle of reflection is the secondary angle light takes when reflected off of some surface. The angle of incidence is equal to the angle of reflection.

Balance. A state of visual symmetry among elements in a photo.

Barebulb flash. A portable flash unit with a vertical flash tube that fires the flash illumination 360 degrees.

Barn doors. Black, metal folding doors that attach to a light's reflector; used to control the width of the beam of light.

Black flag. Light-blocking card that is supported on a stand or boom and positioned between the light source and subject to selectively block light from portions of the scene. Also known as a gobo.

Bounce flash. Bouncing the light of a studio or portable flash off a surface such as a ceiling or wall to produce indirect, shadowless lighting.

Box light. A diffused light source housed in a box-shaped reflector. The bottom of the box is translucent material; the side pieces of the box are opaque, but they are coated with a reflective material such as foil on the inside to optimize light output.

Broad lighting. Style of portrait lighting in which the key light illuminates the side of the subject's face turned toward the camera.

Catchlight. The specular highlights that appear in the iris or pupil of the subject's eyes reflected from the portrait lights.

Closed yearbook. When a school will not permit photos taken by photographers other than the sanctioned one to create yearbook photos.

Composite. An image that includes elements from at least two original photos, and in many cases graphics and type.

Contract photographer. A photographer under contract to photograph all of the yearbook photos for a high school or junior high.

Cross-lighting. Lighting that comes from the side of the subject, skimming facial surfaces to reveal the maximum texture in the skin. Also called side lighting.

Cross-processing. Developing color negative film in color transparency chemistry and vice versa (developing transparency film in color negative chemistry).

Cross-shadows. Shadows created by lighting a group with two light sources from either side of the camera. These should be eliminated to restore the "one-light" look.

Depth of field. The distance that is sharp beyond and in front of the focus point at a given f-stop.

Depth of focus. The amount of sharpness that extends in front of and behind the focus point. Some lenses' depth of focus extends 50 percent in front of and 50 percent behind the focus point. Other lenses may vary.

Diffusion flat. Portable, translucent diffuser that can be positioned in a window frame or near the subject to diffuse the light striking the subject. Also known as a scrim.

Dodging. A darkroom printing technique in which specific areas of the print are given less print exposure by blocking the light to those areas of the print, making those areas lighter.

Dragging the shutter. Using a shutter speed slower than the X-sync speed in order to capture the ambient light in a scene.

Dynamic lines. In composition and posing, the real and implied lines within the image that are not vertical or horizontal. Dynamic lines lend visual interest to the composition of the image.

E.I. Otherwise known as exposure index. The term refers to a film speed other than the rated ISO of the film.

Fashion lighting. Type of lighting that is characterized by its shadowless light and its proximity to the lens axis. Fashion lighting is usually head-on and very soft in quality.

Feathered edge. Also known as the penumbra; the soft edge of the circular light pattern from a light in a parabolic reflector.

Feathering lights. Misdirecting the light deliberately so that the edge of the beam of light illuminates the subject.

Feminine pose. A pose characterized by the head tilted toward the high shoulder.

Fill card. A white or silver-foil-covered card used to reflect light back into the shadow areas of the subject.

Fill light. Secondary light source used to fill in the shadows created by the key light.

Flash-fill. Flash technique that uses electronic flash to fill in the shadows created by the main light source.

Flash key. Flash technique in which the flash becomes the main light source and the ambient light in the scene fills the shadows created by the flash.

Flashmeter. A handheld incident meter measures both the ambient light of a scene and when connected to the main flash, will read flash only or a combination of flash and ambient light. They are invaluable for determining outdoor flash exposures and lighting ratios.

Focusing an umbrella. Adjusting the length of exposed shaft of an umbrella in a light housing to optimize light output.

Foreshortening. A distortion of normal perspective caused by close proximity of the camera/lens to the subject. Foreshortening exaggerates subject features—noses appear elongated, chins jut out, and the backs of heads may appear smaller than normal.

Fresnel lens. The glass filter on a spotlight that concentrates the light rays in a spotlight into a narrow beam of light.

Full-length portrait. A pose that includes the full figure of the model. Full-length portraits can show the subject standing, seated, or reclining.

Furrows. The vertical grooves in the face adjacent to the mouth. Furrows are made deeper when the subject smiles; often called laugh lines.

Gobo. Light-blocking card that is supported on a stand or boom and positioned between the light source and subject to selectively block light from portions of the scene. Also known as a black flag.

Head-and-shoulder axis. Imaginary lines running through shoulders (shoulder axis) and down the ridge of the nose (head axis). The head-and-shoulder axis should never be perpendicular to the lens axis.

High-key lighting. Type of lighting characterized by a low lighting ratio and a predominance of light tones.

Highlight brilliance. The specularity of highlights on the skin. Negatives with good highlight brilliance show specular highlights (paper base white) within a major highlight area. Achieved through good lighting and exposure techniques.

Hot spots. A highlight area of the negative or background in an image that is overexposed and without detail. Sometimes these areas are etched down to a printable density.

Incident light meter. A handheld light meter that measures the amount of light falling on its light-sensitive cell.

Key light. The main light in portraiture used to establish the lighting pattern and define the facial features of the subject.

Kicker. A back light (light from behind the subject) that highlights the hair or contour of the body.

Lead-in line. In compositions, a pleasing line in the scene that leads the viewer's eye toward the main subject.

Lighting contrast. Usually expressed as a lighting ratio; i.e., the difference in intensity between the highlight and shadow in an image.

Lighting ratio. The difference in intensity between the highlight side of the face and the shadow side of the face. A 3:1 ratio implies that the highlight side is three times brighter than the shadow side of the face.

Low-key lighting. Type of lighting characterized by a high-lighting ratio and strong scene contrast as well as a predominance of dark tones.

Main light. Synonymous with key light.

Masculine pose. A pose characterized by the head tilted toward the low shoulder.

Matte box. A front-lens accessory with retractable bellows that holds filters, masks, and vignettes for modifying the image.

Mirror lockup. A feature in many SLR cameras, medium format and 35mm, that allows the reflex mirror to be locked in the up position to avoid camera vibration.

Modeling light. A secondary light mounted in the center of a studio flash head that gives a close approximation of the lighting that the flash tube will produce. Usually high intensity, low-heat output quartz bulbs.

Overlighting. Main light is either too close to the subject, or too intense and oversaturates the skin with light, making it impossible to record detail in highlighted areas. Best corrected by feathering the light or moving it back.

Parabolic reflector. Oval-shaped polished dish that houses a light and directs its beam outward in an evenly controlled manner.

Paramount lighting. One of the basic portrait lighting patterns, characterized by a key light placed high and directly on axis with the line of the subject's nose. This lighting produces a butterfly-shaped shadow under the nose and is also called butterfly lighting.

Perspective. The appearance of objects in a scene as determined by their relative distance and position.

Profile pose. A position in posing where the subject's head is turned 90 degrees from the camera. The pose is characterized by being able to see only one of the subject's eyes.

Push-processing. Extended development of film, sometimes in a special developer, that increases the effective speed of the film.

Reflected light meter. A meter that measures the amount of light reflected from a surface or scene. All in-camera meters are of the reflected type.

Reflector. (1) Same as fill card. (2) A housing on a light that reflects the light outward in a controlled beam.

Rim lighting. Portrait lighting pattern where the key light is behind the subject and illuminates the edge of the subject. Most often used with profile poses.

Ringlight flash. A flash with a circular tube surrounding the lens. Used in fashion photography and macrophotography of specimens.

Rule of thirds. Format for composition that divides the image area into thirds, horizontally and vertically. The intersection of two lines is a dynamic point where the subject should be placed for the most visual impact.

Scene contrast. The overall contrast of a scene as determined by the lightest and darkest values within the scene.

Scrim. A panel used to diffuse sunlight. Scrims can be mounted in panels and set in windows, used on stands, or suspended in front of a light source to diffuse the light.

Seven-eighths view. Facial pose that shows approximately seven-eighths of the face. Almost a full-face view as seen from the camera.

Shadow. An area of the scene on which no direct light is falling, making it darker than areas receiving direct light (i.e., highlights).

Short lighting. Style of portrait lighting in which the key light illuminates the side of the face turned away from the camera.

Slave. An optical, or radio-controlled remote triggering device used to fire auxiliary flash units.

Soft-focus lens. Special lens that uses spherical or chromatic aberration in its design to diffuse the image points.

Specular highlights. Sharp, dense image points on the negative. Specular highlights are very small and usually appear on pores in the skin.

Split lighting. Type of portrait lighting that splits the face into two distinct areas: shadow side and highlight side. The key light is placed far to the side of the subject and slightly higher than the subject's head height.

Spotmeter. A reflected light meter that measures a narrow angle of view—normally 1 to 5 degrees.

Spots/spotlights. A small, sharp light that uses a Fresnel lens to focus the light from the housing into a narrow beam.

Straight flash. The light of an on-camera flash unit that is used without diffusion; i.e., straight.

Subtractive fill-in. Lighting technique that uses a black card to subtract light out of a subject area in order to create a better defined lighting ratio. Also refers to the placement of a black card over the subject in outdoor portraiture to make the light more frontal and less overhead.

Tension. A state of visual imbalance within a photograph.

Three-quarter-length pose. Pose that includes all but the lower portion of the subject's anatomy. Can be from above the knees and up, or below the knees and up.

Three-quarters view. Facial pose that allows the camera to see three-quarters of the facial area. The subject's face is usually turned 45 degrees away from the lens so the far ear disappears from camera view.

Tooth. Refers to a negative that has a built-in retouching surface that will accept retouching leads.

TTL-balanced fill-flash. Flash exposure systems that read the flash exposure through the camera lens and adjust flash output to compensate for flash and ambient light exposures, producing a balanced exposure.

Transvues. 35mm slides made from the customer's negatives at the time of original processing. These slides are used to proof the job instead of releasing paper proofs.

Triangle base. The combination of head, torso, and arms that forms the basic compositional form in portraiture.

Two-thirds view. A view of the face that is between three-quarter view and seven-eighths view. Many photographers do not recognize these distinctions—anything not a head-on facial view or a profile is a two-thirds view.

Umbra. The hot center portion of the light pattern from an undiffused light in a parabolic reflector.

Umbrella lighting. Type of soft, casual lighting that uses one or more photographic umbrellas to diffuse the light source(s).

Vignette. A semicircular, soft-edged border around the main subject. Vignettes can be either light or dark in tone and can be included at the time of shooting, or added later in printing.

Visual weight. A compositional element that places visual emphasis on it.

Watt-seconds. Numerical system used to rate the power output of electronic flash units. Primarily used to rate studio strobe systems.

Wraparound lighting. Soft type of light, produced by umbrellas, that wraps around the subject, producing a low lighting ratio and open, well-illuminated highlight areas.

X-sync. The shutter speed at which focal-plane shutters synchronize with electronic flash.

Zebra. A term used to describe reflectors or umbrellas having alternating reflecting materials such as silver and white cloth.

DIGITAL PORTRAIT PHOTOGRAPHY OF
TEENS AND SENIORS
Patrick Rice

Learn the techniques top professionals use to shoot and sell portraits of teens and high-school seniors! Includes tips for every phase of the digital process. $34.95 list, 8½x11, 128p, 200 color photos, index, order no. 1803.

MARKETING & SELLING TECHNIQUES
FOR DIGITAL PORTRAIT PHOTOGRAPHY
Kathleen Hawkins

Great portraits aren't enough to ensure the success of your business! Learn how to attract clients and boost your sales. $34.95 list, 8½x11, 128p, 150 color photos, index, order no. 1804.

DIGITAL PHOTOGRAPHY BOOT CAMP
Kevin Kubota

Kevin Kubota's popular workshop is now a book! A down-and-dirty, step-by-step course in building a professional photography workflow and creating digital images that sell! $34.95 list, 8½x11, 128p, 250 color images, index, order no. 1809.

PROFESSIONAL POSING TECHNIQUES FOR WEDDING AND
PORTRAIT PHOTOGRAPHERS
Norman Phillips

Master the techniques you need to pose subjects successfully—whether you are working with men, women, children, or groups. $34.95 list, 8½x11, 128p, 260 color photos, index, order no. 1810.

PROFESSIONAL MARKETING & SELLING TECHNIQUES
FOR DIGITAL WEDDING PHOTOGRAPHERS,
SECOND EDITION
Jeff Hawkins and Kathleen Hawkins

Taking great photos isn't enough to ensure success! Become a master marketer and salesperson with these easy techniques. $34.95 list, 8½x11, 128p, 150 color photos, index, order no. 1815.

HOW TO CREATE A **HIGH PROFIT PHOTOGRAPHY BUSINESS**
IN ANY MARKET
James Williams

Whether your studio is located in a rural or urban area, you'll learn to identify your ideal client type, create the images they want, and watch your financial and artistic dreams spring to life! $34.95 list, 8½x11, 128p, 200 color photos, index, order no. 1819.

MASTER LIGHTING TECHNIQUES
FOR OUTDOOR AND LOCATION DIGITAL PORTRAIT PHOTOGRAPHY
Stephen A. Dantzig

Use natural light alone or with flash fill, bare-bulb, and strobes to shoot perfect portraits all day long. $34.95 list, 8½x11, 128p, 175 color photos, diagrams, index, order no. 1821.

ARTISTIC TECHNIQUES WITH ADOBE® PHOTOSHOP® AND COREL® PAINTER®
Deborah Lynn Ferro

Flex your creative skills and learn how to transform photographs into fine-art masterpieces. Step-by-step techniques make it easy! $34.95 list, 8½x11, 128p, 200 color images, index, order no. 1806.

PROFESSIONAL PORTRAIT LIGHTING
TECHNIQUES AND IMAGES FROM MASTER PHOTOGRAPHERS
Michelle Perkins

Get a behind-the-scenes look at the lighting techniques employed by the world's top portrait photographers. $34.95 list, 8½x11, 128p, 200 color photos, index, order no. 2000.